Chicago's Nelson Algren

PHOTOGRAPHS AND TEXT BY ART SHAY

FOREWORD BY DAVID MAMET

SEVEN STORIES PRESS NEW YORK • LONDON • MELBOURNE • TORONTO

Seven Stories Press
140 Watts Street
New York, NY 10013
http://www.sevenstories.com

In Canada: Publishers Group Canada, 559 College Street, Suite 402, Toronto, ON M6G 1A9

In the U.K.: Turnaround Publisher Services Ltd., Unit 3, Olympia Trading Estate, Coburg Road, Wood Green, London N22 6TZ

In Australia: Palgrave Macmillan, 627 Chapel Street, South Yarra, VIC 3141

Library of Congress Cataloging-in-Publication Data:

Shay, Arthur.
 Chicago's Nelson Algren / photos and text by Art Shay ; foreword by David Mamet.
 p. cm.
 "First version of this book, Nelson Algren's Chicago."
 ISBN 978-1-58322-764-0 (pbk.)
1. Chicago (Ill.)--Pictorial works. 2. Chicago (Ill.)--Social life and customs--Pictorial works. 3. Algren, Nelson, 1909-1981--Photograph collections. I. Shay, Arthur. Nelson Algren's Chicago. II. Title.

F548.37.S517 2007
977.3'110440222--dc22
 2007011514

College professors may order examination copies of Seven Stories Press titles for a free six-month trial period. To order, visit http://www.sevenstories.com/textbook/ or send a fax on school letterhead to 212.226.1411.

Book design by Jon Gilbert

Scans by JSGraphics, Chicago

Printed in the U.S.A.

9 8 7 6 5 4 3 2 1

This book, like its predecessor, is for Harmon Shay, my wonderful lost son and Nelson Algren's godson, who disappeared into the hippie wild side at age 21 in 1972. It is also for Dr. Larry Michaelis and his cardiac team at Northwestern Memorial Hospital who gave me the heart—the pig's valve for it anyway—to finish the first version of this work. The porcine replacement part lasted eighteen years. Additional thanks are due to the succeeding heart valve team at Evanston Hospital, Doctors Timothy Votapka and Irwin Silverman, and to my lifelong brilliant, forgiving, sweetheart of a wife, Florence, who still relishes Nelson's drunken characterization of her at one of our New Year's parties: "In Poland you could easily have been the smart, attractive Jewish harlot they hired to bring in the richer peasants."

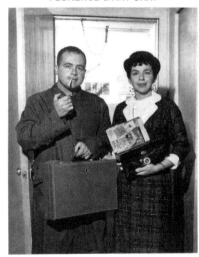

Happy Everything!

FLORENCE & ART SHAY

Hunting the Vegas Mafia
With 5 Hidden Cameras. 1962

Contents

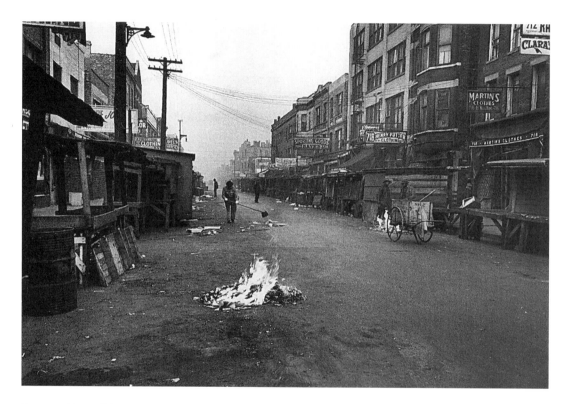

Dawn on Maxwell Street, 1949.

Foreword

I hear the Chicago accent, and I am a gone goose. Decades of living away, acting school, speech lessons, and the desire to make myself understood in a wider world are gone, and I am saying *dese*, *dem* and *dose*, and am back on the corner, tapping the other fellow on the forearm to make my point, and happy. Art Shay's writing, and his photos, have the Chicago accent, which may be to say he's telling you the truth as he knows it, as what right-thinking person would consider doing anything else?

I remember Algren's Chicago. I remember Algren, sitting alone, in the back at Second City, regularly. I remember the pawnshops on West Madison Street— I used to shop there; Sundays at Maxwell Street, and the vendors pulling on your arm and talking in Yiddish; police headquarters at 11th and State, and getting dragged down there on this or that bogus roust when I drove a cab. Art's photographs are so real that I reflect that *it*, like them, must have all occurred in black and white.

I think it takes a realist to see the humor in things. I know it takes a realist to see the depth of tragedy. Art's work feels like the guy tapping me on the forearm.

—David Mamet

Preface

After conferring with John O'Hara, the Rolls-Royce-driving, spats-wearing Bard of the Barflies, the chief literary critic of the *New York Times*, Havey Breit, quixotically observed, "American writers don't *look* like writers." "Nelson Algren," Breit added, "doesn't even sound like one."

Breit must have noticed my pal Nelson's frayed rope belt and Salvation Army jacket at that point, because he observed, "He looks like any guy—medium height, medium slim, medium sandy hair—and can be anything: a clerk, a sailor, a baker's boy, a soda jerk, a bus driver. But not a writer. Obviously Mr. Algren *is* a writer, a very good one."

Papa Hemingway himself had just read Algren's latest novel, *The Man with the Golden Arm*, when he added his two cents' worth: "Into a world of letters where we have the fading Faulkner and where that overgrown Lil Abner Thomas Wolfe casts a shorter shadow each day, Nelson Algren comes like a corvette or even a big destroyer when one of these things is what you need and need it badly and at once and for keeps. He has been around for a long time but only the pros know him. . . . This is a man writing and you should not read it if you can't take a punch. I doubt if any of you can. Mr. Algren can hit with both hands and move around and he will kill you if you are not awfully careful. . . . Boy, Mr. Algren, you are good."

It is now about sixty years since Nelson and I wandered Chicago and its lower depths for the first version of this book, *Nelson Algren's Chicago*. While digging

out negatives from the Forties and Fifties for the Stephen Daiter Gallery in Chicago, and working with Leigh Moran of the Chicago History Museum for a retrospective show of my work, archivist Erica DeGlopper and I found a dozen prints on whose reverse side Nelson had written captions. Erica also unearthed many negatives I'd long forgotten, including pictures of Nelson's haunts, him with friends and street people, and several frames of his "Frenchy," Simone de Beauvoir, nude. I have shuffled and sorted the poker hand of my newly surfaced images with the older ones for the book you are holding.

Nelson was a man who loved beginning projects. He was only a C- finisher. He wanted to call the first version of this book *Chicago: Its Deeps, Steeps and Creeps*. His introduction began:

> These pictures prove nothin' not already proven in poetry and prose: that Chicago is not only a writers' an' fighters' town, not only the place of great punchers and counter-punchers and the home of poets with cello strings drawn tautly across their hearts, but something more, and something less, than the home of poets and mugs.
>
> More than the place of the big-time thieves who never do time, the flawless outfielders and the welterweights who go blind in their own blood and stay, and stay to win in their own blood at last. More than that, the place of the classic invincibles, whether the power is in a .38, a pair of six-ouncers or a typewriter ribbon: Tony Zale or Vachel Lindsay, Yellow Kid Weil, Barney Ross, Carl Sandburg, Harriet Monroe, or Grover Cleveland Alexander.

More than the home grounds, too, of the great natural bums, the ones who faint open-eyed on the ropes without a blow being struck and the ones who drop the ninth inning pop-up with two gone and a nine run lead, to let the next ten runners score.

A few days later Nelson advised me to "tear up those notes I gave you," and handed me a new sheaf. It began:

If You Don't Like These Pictures, Get Your Own Damned Camera
It's always been a writer's town and it's always been a fighter's town, an artist's town and a torpedo's town. The most artistic characters in the strong-arm industry as well as the world's most muscular poets got that way by just growing up in Chicago. Whether you're in the local writing racket or the burglary line, if you're not a bull then you'd better be a fox.

It's a joint where the bulls and the foxes live well but the lambs wind up head down from the hook in the stockyard. On the morning that the meek inherit the rest of the earth, they'll be lining up here for unemployment insurance.

It's a town where the writer of class and the swifter-type thief approach their work with the same lofty hope of slipping a fast one over. "If he can get away with it, I give him credit," it is said here of bad poets as well as of good safe-blowers. Write, paint, steal the town blind, or merely take photographs of the people on its streets—so long as you make your oper-

ation pay off you'll count nothing but dividends and hear nothing but cheers.

I like to think that including photographers along with the writers of class, the good safe-blowers and the (bad) poets was Nelson's way of saying he liked my pictures and I shouldn't be ashamed of taking good money for them from white-bread magazines, companies like Ford, and galleries.

Nelson never forgot that "the most American of all American cities" had been wrested by white con men and brigands from the Pottawatomie and that succeeding generations of rough traders of everything from furs to flesh and whiskey had used the felicitous confluence of the Chicago River and Lake Michigan to their benefit.

So, back we go . . .

Heading south on the Kennedy Expressway, day or night, once you pass Fullerton Avenue, the ever-changing skyline of brawny Chicago looms as a broken-toothed parenthesis of steel, glass, and concrete stretching east and west. Whether catching the last gold of sunlight or the twilight gleam of window lights burning through a myriad of varying sunsets and dawns, the city is a constantly changing delight to my photographer's eye, a city that stretches from the John Hancock Building and the Gold Coast on the left all the way across the vaunted Loop to the world's tallest building, the Sears Tower, just about dead ahead.

The moment I cross Fullerton I glide over to the left lane and in a few seconds cross what was once the short stretch of Wabansia Avenue that intersected

North Bosworth. Rolling over that sector of long-gone Wabansia, the part that was eminent-domained by Mayor Daley's myrmidons and turned from mangy gray two-flats into mangier gray roadway to hurry us Loop-ward, I think of Chicago novelist Nelson Algren and French novelist-philosopher Simone de Beauvoir, who occupied that precise space more than half a century ago, sharing Algren's squeaky bed on the second floor of 1523 Wabansia. An air space vacated so long ago that five billion cars have since occupied it momentarily, hurrying toward the city with which Algren had a lifelong love-hate affair.

"It isn't hard to love a town for its greater and its lesser towers," Algren wrote,

its pleasant parks or its flashing ballet. Or for its broad and bending boulevards, where the continuous headlights follow, one dark driver after the next, one swift car after another, all night, all night, and all night. But you never truly love it till you can love its alleys too. Where the bright and morning faces of old familiar friends now wear the anxious midnight eyes of strangers a long way from home.

A midnight bounded by the bright carnival of the boulevards and the dark girders of the El.

Where once the marshland came to flower.

Where once the deer came down to water.

But that was nearly sixty years ago.

I was a young *Life* magazine staff reporter, pitching a story on Algren, "the prose poet of the Chicago slums." "I'll wander around with him and show him

with his friends from the lower depths of Chicago, gamblers, whores, drug addicts, losers, thieves, cops . . . night people." I had always loved the camera, owned a Rolleiflex and a Leica, had worked with many of *Life*'s great photographers, and was about to leave the magazine anyway to become a photojournalist, a relatively new profession in 1949. Thus it was merely a short leap into gearing up for a speculative photo essay on Algren, shooting my own pictures. Nelson liked the idea—even though *Life* eventually rejected it—and we became friends. For a decade and a half, as things turned out, I more or less documented his life in Chicago.

Driving through the air space he once occupied, as I do several times a week, my thoughts continue to reel backward . . .

I see Algren and de Beauvoir fucking their extraordinary brains out, and then discussing Camus' ultimately granted death wish and Jean-Paul Sartre's declining health, especially his failing prostate and the effect it was having on his sleeping with young, admiring students; Brigitte Bardot's cultural significance and matchless derrière (which Algren hinted attracted de Beauvoir as something more than a work of art) and her preference for animals over people; the Chicago White Sox (de Beauvoir "liked the story of the Black Sox scandal," he wrote, "because it was so American in its corruption for money—as if this was unheard of in France"). It was on Algren that de Beauvoir first tried her thesis on the oppression of women that became *The Second Sex* ("She feels woman is something between man and eunuch," he reported, shrugging. "But she's quite a lady in the sack"). He had been put off by her philosophy as expressed in her only work then in English, *The Ethics of Ambiguity*: "If you can make sense of

it," Algren said, giving me his copy, "send me a postcard. If she didn't think I was so great in the sack and had a great mind I'd send her back to Sartre. Listen to this: 'The doctrine of necessity is much more a weapon than faith. The supreme end at which man must aim is freedom, which alone is capable of establishing the value of every end.' You should hear her on Kant and Hegel—and she never slept with either of those cats."

"Frenchy," as he introduced her, enjoyed hanging around with Algren and most especially enjoyed going to police line-ups where the suspects stood against a wall and a bored sergeant interrogated them. Algren used a tattered entrance ticket given to him years before when his Schwinn bike was stolen from a Wabansia alley. He and his guest were presumably still searching for the thief.

My peregrinations with Algren began when he had just turned forty. The greatest prose poet Chicago has yet produced was tall and lean then, an amalgam of Robert Mitchum and Kirk Douglas with a healthy dash of Woody Allen. His voice was soft, self-mocking, and humorous, with a vein of irony running beneath almost everything he said. He was wearing a sleeveless khaki undershirt when I arrived. He put on water to boil for tea and was instantly cooperative as I whipped out my Leica. "You don't want me to get the dirty dishes out of the sink, do you?" I said we'd wander through his haunts. Milwaukee Avenue with its Polish resonances was on my list—the street that, along with Ashland Avenue and Clark, Division, and Madison streets, figured in his new novel, *The Man with the Golden Arm*, that was fast making him the king of the literary jungle that year. I met Frenchy and photographed the two of them in the alley. I even photographed his gray and white cat named Doubleday, after his publishers.

Nelson Algren's abiding interest and the focus of his major work was and would remain Chicago. He had grown up in the city during hard times, and though he sometimes wandered off, he always returned to its underside and the terrible plight of his beloved city's unlucky poor. Twice as introductions to his own works he quoted Walt Whitman:

> I feel I am of them—
> I belong to these convicts and prostitutes myself
> And henceforth I will not deny them—
> For how can I deny myself?

As we worked, Algren denied neither them nor himself. Day or night, he called me whenever he was about to do something interesting or just felt the urge to wander around. Camera at the ready, I accompanied him up and down Chicago's meanest streets, into bars long since shut down, like The Shamrock on Clark Street, which were hardly hospitable to cameras or squares like me . . .

The magazine piece that became *Chicago: City on the Make* came about after *Holiday* editors Louis F. V. Mercier and Harry Sions called from Philadelphia to ask me to recommend "a good Chicago writer," since I'd be doing some of the pictures for an upcoming issue about Chicago. I gave them Algren's number. Joking, he told them to check his credentials with Carl Sandburg, then strumming his guitar and raising goats on his farm in North Carolina. They did so. Sandburg gave Algren high marks and the project was on.

The whole thing would give Sions many an anxious moment, after it became

apparent that Algren would not permit any but minor changes—and he didn't share Sion's concern about offending advertisers or the municipal powers who could discourage advertisers from buying space in an issue that knocked Chicago. The title for the book that came of the article was born in my 1949 Pontiac around Hammond, Indiana, as I drove Algren and Doubleday's editor in chief, Ken McCormick, to Algren's house at Miller's Beach. Algren, pondering the title, said, "I've always thought of Chicago as a hustler's city." McCormick replied, "Yes, it's a tough, working-class city, a sort of city on the make, a—" "That's it," I interrupted. "That's the title." Later Algren posed for a gag snapshot of himself carrying McCormick's bags into the house, acting as his lackey.

From the ending of *Chicago: City on the Make*:

A rumor of neon flowers, bleeding all night long, along those tracks where endless locals pass. . . .

Between the curved steel of the El and the nearest Clark Street hockshop, between the penny arcade and the shooting gallery, between the basement grill and the biggest juke in Bronzeville, the prairie is caught for keeps at last. Yet on nights when the blood-red neon of the tavern legends tether the arc-lamps to all the puddles left from last night's rain, somewhere between the bright carnival of the boulevards and the dark girders of the El, ever so far and ever so faintly between the still grasses and the moving waters, clear as a cat's cry on a midnight wind, the Pottawatomies mourn in the river reeds once more.

That "clear as a cat's cry on the midnight wind" reminds me how much Algren loved cats. He had Doubleday; he drew pictures of cats in the front or back of the books he autographed for many friends. He wrote of cats in *Somebody in Boots* (a woman "pawing through a garbage barrel like an angular cat") and drew a dorsal view of a perky tail-thumping tom for the last page of his last book. He wrote about drunks, bums, whores, pimps, addicts, and other losers who would wake up looking at cats. Algren admired the cat's street smarts, I think, its wily will to survive and its independence in a world not of its making. I photographed Algren playing poker in a Division Street joint and met several of the people he had coalesced, or would metamorphose, into fictional characters, including a legless man who rolled himself around on a little cart. Spotting him one day on West Madison I asked, "Is that the guy?" "They all look alike," said Algren.

An East St. Louis drug addict agreed to demonstrate the technique of a heroin fix. "Bad idea," Algren said afterward. "He's been off it a while. Posing got him too excited."

I followed Algren to Riccardo's on North Rush Street, where (with de Beauvoir back in Paris) he dined with a gorgeous black actress named Janice Kingslow who once had played the lead in a Chicago company's production of *Anna Lucasta*. Another of his lady friends was Mari Sabusawa, a pretty Nisei who later married James Michener.

Algren had married Amanda Kontowicz in 1937. They were divorced in 1946, and would remarry in 1953, after Algren finally came to understand that de Beauvoir wasn't leaving Sartre anytime soon, and divorced again in 1955.

Algren would stay single until 1965, when he married actress Betty Bendyk, only to divorce three years later. He would have no children from any of the marriages to either woman.

We sneaked into the Washem School of Undertaking and the Cook County morgue, my camera hidden. We shot on the streets, in Bughouse Square, in skid-row hotels, in all-night restaurants and touch bars, in tattoo parlors. We even took pictures at the ancient city office building on West Hubbard where he'd worked for the Department of Health in the VD division.

Algren's lifelong habitats had been Cottage Grove Avenue, Wabansia Avenue, Noble Street, Evergreen Street, and Miller's Beach near Gary, Indiana, and he had a poor boy's awe of good living. I picked him up one morning as he left actress Geraldine Page's hotel suite on North State Street and he was obviously starry-eyed—not merely with Page, whom he regarded as one of the greatest women alive, on stage and off, but with the suite. "Everything is so clean up there. We had breakfast on this heavy linen, and even the lid on the marmalade jar was polished"—he loved orange marmalade with his tea, and after having some he would pick the bits of rind from his poor teeth with soft Stimudent toothpicks—"and there were these red flowers. Even they were clean."

One of his dreams, inspired by a fellow scrivener, the author of *What Makes Sammy Run?*, was to "own" a boxer "like Budd Schulberg does," and be ringside for the fights. Or to own a racehorse, "to give me something to do at the track instead of losing or stooping." We did an article for *Sports Illustrated* on "stoopers," horseplayers who comb the clubhouse floors for winning tickets thrown away by inexperienced bettors. And Algren did buy a horse, a loser named Jeal-

ous Widow, a.k.a. Algren's Folly, and kept her at Cahokia Downs in Belleville the summer of 1970.

Another of Algren's dreams was to run a poker game and to be the top dealer. He was only a fair player but thought himself a master.

He also had a strange desire to be a landlord, a proprietor of places like the ones in which he played poker or under whose parsimony he himself had dwelled.

In 1957, shortly after *Wild Side* came out, Algren and I drove to New York in my 1954 Hudson Jet. He was casting about for a new agent, having gone through several financial disasters with his original agent, Madeleine Brennan, who had let him sign away the movie rights to *The Man with the Golden Arm* for a mere $15,000. Algren was going to stay with a young lady who had written him a sexy fan letter. He and I met a couple of nights later to see Eugene O'Neill's *Long Day's Journey into Night*. Near the end of the interminable first act he whispered, "I've been here so long I feel like I'm a member of the O'Neill family." After the play Algren looked at me strangely. "There's a guy been following me. Says he's one of Charlie Feldman's guys. Nice guy. Very persistent. He wants to give me $25,000 for *Wild Side*."

"Good God!" I said. "Hold off until you get a new agent." I knew he had an appointment with Shirley Fisher of the classy McIntosh and Otis agency in the next day or so.

A couple of nights later Algren called. "Oh, I sold it," he said. "It was the best way to get rid of the guy. He was interfering with my social life."

Algren returned to Chicago with the $25,000 check for *Wild Side*. He had a

poor man's suspicion of banks so he cashed the check and stored the money in brown bags at his friend and neighbor, radio writer Dave Peltz's house. He went to a Milwaukee Avenue real estate office, and for $16,000 bought the four-story apartment building with coach house that stands on the corner of Wisconsin Street and North Lincoln Avenue, just north of the Lincoln Hotel. A landlord at last!

One dark 3 A.M., Algren, a habitual night owl, called. "Where can I get a used refrigerator for around $80?" During a moment of passion with one of his tenants, the ever-generous womanizer had promised a better refrigerator than the current Norge. I helped him find one, but between purchase and delivery Algren decided he couldn't hack the responsibility of landlordhood or of his generosity—and he sold the building back to his real estate agent for $13,500. One of his better deals, actually. He had lost a mere $2,500 in six weeks. It's worth three million bucks today, and the income from it, had he held on, would have kept him out of penury and, most likely, from leaving Chicago.

Each time he wanted to go to the Washington Park racetrack, he would get some cash from one of the paper bags. "When the leaves turned brown that year," Peltz said with radio-voice dolor, "all the money was gone."

He'd done even worse with the film rights for *The Man with a Golden Arm*. The rights he'd sold for $15,000 ended up costing producer-director Otto Preminger $100,000, according to Preminger. All Algren got was several futile lawsuits and a chance to work one week for $725 for Preminger on the script—you can read Algren's slapstick account of that chapter in his life in *The Last Carousel*—and to learn about Hollywood what Faulkner, Nathanael West, and

F. Scott Fitzgerald figured out during longer sentences, that the air out there isn't necessarily healthy for real writers. Algren hated the way Frank Sinatra played Frankie Machine in Preminger's *Golden Arm*, especially when he lurched wildly coming off a drug fix. Algren said he should have been "on the nod." He also didn't like the way Kim Novak or anyone else in the movie was dressed. One night we were driving by a North Broadway movie house where *Golden Arm* was playing and I gingerly asked Algren if he'd pose in front of the marquee. "What's that movie got to do with me?" he asked icily.

Once, in 1953, Algren stayed over for breakfast at the northside apartment on Rosedale Avenue that I shared with my wife, Florence; our five-year-old daughter, Jane; Nelson's godson, Harmon; and our newborn, Richard. As we sat at the table reading the morning paper, a front-page story illustrated by two pictures caught Algren's eye. Two large white coffins and three small ones were arrayed in a church. A hitchhiker had murdered a father, mother, and three children. Next to this picture was a close-up of the killer, who was holding his knuckles up to the camera. On each of the eight knuckles was tattooed a letter, H-A-R-D-L-U-C-K.

Algren looked at the picture and said, "That poor S.O.B."

My wife didn't understand him at first.

"You mean the father?" she said.

"No, the hitchhiker."

As my wife swatted him with the paper, Algren, surprised, said, "Can you imagine what it took to make a guy do a thing like that?"

"I never believed in God," Algren once told me, "after I saw a doctor saw through a corpse's head."

He told biographers Martha Heasley Cox and Wayne Chatterton how as a youth he once went into a spiritual phase in which all pleasures were banned. "The difficulty with sustaining this level of high-mindedness—indeed righteousness—was that when you fell off, you went awfully far. The more nobly you lived, the deeper the abyss of sin became—and the more appealing. I was certainly a mixed-up kid."

Not all that mixed-up. His older sister financed his admission to the University of Illinois, where he worked on the college newspaper, then called the *Illini*, and graduated in 1931 with a degree in journalism.

"What was your IQ?" I once asked him. "Ninety-six," he said. "I just never finished the test. They kept asking you how many cubes were stacked up. How could you assume there were any cubes behind the first row if you couldn't see 'em? I kept trying to figure this out and never did. . . ."

One day Algren showed me an Ontario Street building in which the gallows for escapee Tommy O'Connor was stored. The city never found O'Connor, but the gallows was saved just in case he turned up. Algren admired O'Connor's feat. He was a loser who finally won, a Chicago cat with yet another life. An agile man from daily boxing workouts at the Division Street Y—he punched the heavy bag like a demon—Algren pulled himself over the high window sill in this building and peered in. "Can't see it, but that's where it is," he reported.

In those days, before each courtroom had armed security guards, it was easy to wander through the courts with a camera. Algren loved to listen to the wild stories of people on trial, and his contempt for lawyers was equal to Daumier's. He felt, as I did, that the candid camera around the courts at Eleventh and State and Twenty-sixth and California was doing the same job Daumier's sketchpad did around the courts of Paris a century earlier—documenting the further oppression of the already oppressed.

In his notes for the introduction to the Doubleday photo book that never would be, Algren wrote:

[Chicago] is also the most American of cities because it is in the faces of its strays that we see, more clearly than in any other American city, the special, the secret American guilt of owning nothing, nothing at all, in the one land where ownership and virtue are one. Guilt that lies crouched behind every billboard demanding whether or not there is a Ford in your future.

These are pictures of people who have failed the billboards all down the line. Neither a Ford in this one's future nor one small room of his own. . . . These are the unholy mugs and phizzes of those who have failed even by barroom standards. . . . Their very lives give off a jailhouse odor: It trails down the streets of Skid Row behind them till the city itself seems some sort of gray-roofed jail with walls for all men and laughter for very few.

"Artistic literature," Chekhov said, "is called so because it depicts life as it really is. It aims at truth, unconditional and honest. . . ."

Sorting through our pictures of addicts and winos, prisoners and courtroom denizens, Algren invoked Chekhov again: "What would you say if a newspaper reporter because of his fastidiousness were to describe only honest mayors, high-minded ladies, and virtuous contractors? To the chemist nothing on earth is unclean." Or to God, or Algren, I guessed, still shaken by his sympathy for the tattooed hitchhiker.

I began editing two sets of pictures of Algren in his world, one for *Life* magazine, on the thirty-first floor of the Time-Life Building in New York, and the other for Doubleday, by chance on the sixth floor of the same building. Nelson's publishers suddenly became interested in doing an expensive picture book on Algren, especially now that *The Man with the Golden Arm* was a finalist for the first National Book Award for fiction.

Life laid out the photo essay for eight pages. There was Algren playing cards, being picked up by a woman for an afternoon party, in a low-down joint, at Riccardo's, in the country morgue near a sign adjuring one against handling the bodies without permission. While I was in New York, word got out that he had won the book award and the magazine assigned me to photograph Algren receiving his little gold medal and the thousand dollar check from Eleanor Roosevelt at a Waldorf-Astoria gathering of New York's book people. I also photographed the prize-winning author shopping beforehand for a rented tuxedo in a Sixth Avenue joint.

I introduced Algren to several of the Ivy League *Life* editors working on our story. I'd described him as a poet of the slums, a tough denizen of the underside of Chicago, but he came on as an affable, professional sociologist. When asked

if the woman in this book's cover photo was a whore, Algren said, "Not necessarily. Just because a woman wants to party in the afternoon and needs three bucks don't make her a whore."

After *Life's* lawyers saw the pictures they sent me back to Chicago to get signed one-dollar releases from every bum, addict, and nonwhore in the story. I wandered Chicago for a week searching for these characters, like a man in a novel, holding up pictures, asking one bum if he knew where I could find another. I signed up a goodly number of my subjects, including the nonwhore who overcharged me for the release but admitted she had turned pro.

The Algren story was set to roll off the presses the morning after I delivered the releases. Back in Chicago I waited at R. R. Donnelley and Sons. The presses rolled but off came a photo essay on life in a Mexican prison that granted conjugal rights to prisoners. That was *Life's* sociological story for the time being. The editors kept the Algren pictures for six months then returned them with a note about how tough a subject drug addiction was. Doubleday had hoped the photo essay would create a demand for an Algren photo book—they also had lawyers who wanted releases from all our photogenic addicts—but when *Life* dropped us, they did too. We were allowed to keep our advances, but the book was dead.

Algren and I pitched the book to another publisher, and in one comic version of our proposal he added, "By Arthur Algren and Nelson Shay." Here is our original prospectus, published for the first time.

Nobody's Old Chicago

A photo-book presenting a city that has never been photographed because it has never been acknowledged. Not a town of TV VIPs featuring a mile-high skyscraper by Frank Lloyd Wright. Not one whose iron motto is "I WILL." But rather, one that doesn't begin till the boulevards end; whose tin-can motto seems to be, "Man, I just can't."

That goes down dead-end streets too narrow for a fin-bearing car that sometimes ends in a warehouse wall; or up a backwall fire-escape past kitchens whose lighting is still by gas; down carpetless halls with spook-green walls where doors are numbered even and odd and someone is living behind every door.

Across tracks where boxcars keep shunting all night long. Where somewhere, in the hour between the dog and the wolf before the big homecoming stars come out, when billboards still stream from last night's rain and even street corner ghosts have gone home, down into those rain caves under the walks, below the traffic's iron cries, where a cellophane moon casts a misting light and jukebox cats sit dreaming.

New York is the place where they bind books and write the blurbs and arrange the publicity and print the galleys. It is the place where they hire the people who hire the people. Or where the plain girl with the plain voice from the plain place who has been riding Greyhounds between one-night stands for years, blooms into a TV beauty over-night with her own program and sells a million records and never rides Greyhounds any more.

But Chicago is the place where the book is lived out before it is bound and the song is sung before it is recorded.

A town that doesn't travel by Chrysler; neither does it travel by Caddy, but goes, as the wind goes, on the back of a rag-picking wind down the loneliest streets yet laid down by man: where doors are double-locked against night and the stranger: all signs warn: Keep Out.

A city of nobodies who never sleep but sit between the red juke and the white: sometimes they stir the bourbon, sometimes they chunk the ice. All those who come, with their green years wasted, to beat on the bar with swizzle sticks: to measure their night-blue hours. Weary old weirdies and zigzagging zanies, roam-the-night nomads and break-of-dawn kooks. Some on the nod and some on the hunt, come to the bars of the wilderness under a paper moon wrapped by DuPont.

A city of left-behinders who don't wear gray flannel because they not only don't matter, they know they don't matter: So they put on anything that will cover the skin.

It is also a book that will try to put eyes in the forest of Light House-keeping Rooms, searching out the trades that those who live there live by: the honkytonker, the dance instructor, the past-poster, the race-track stooper, the maimed, the tortured, and the sly: the pinball champ and the sidewalk busker, singbo ad master and the man on wheels. Also the family man who works in a factory all day and works as a sparring partner Saturday mornings. The jockey's valet and the spitback girl, the dope peddler, the hoodlum, the gangster because all he is doing is doing what we say is

right: he is going to get all he can, by any means he can, because it isn't how you get it that counts and nobody is going to ask how.

The book will also try to show how men and women succeed in staying human under the most dehumanizing circumstances.

It will also hope to show that Chicago is perhaps the most universal of all cities, of all cities the one most like man himself in getting back on its feet, wiping off the blood and grinning around the board, asking, "What did he hit me with?"

The now-defunct Pennington Press, in Cleveland, bought the photographs and text and printed 10,000 book jackets as a start. Per our contract the title was *The World of Nelson Algren*, yet one morning Algren called to say that it was a great jacket but he wanted to change the title to *Chicago: Its Deeps, Steeps, and Creeps*. He abominated the young Bob Pennington, ever since his comment, "I skim-read a few of your books, Nelson. You're great." "Let's just give him a few pictures and the opening chapter," Algren said, "and tell him that's the book." He didn't like the guy or his company, but he needed the advance.

It became a standoff, during which we offered Pennington a chance to hire us for $5,000 a shot to do books on poverty in any city that had a good hotel. Nothing came of that notion until 1963, when Macmillan published Algren's "guide to the seamier sides of New York City, Inner London, Paris, Dublin, Barcelona, Seville, Almeria, Istanbul, and Chicago, Illinois," a wildly humorous, pictureless book called *Who Lost an American?*

Our photo essay didn't run and our book wasn't published and our TV play is a roll of tape in my bottom drawer, yet Algren and I stayed in touch, not always happily. When a paragraph was mistakenly added to an announcement of an exhibition of my photographs that said I was working on a then-current project with Algren, he fired off a corrective telegram to the gallery. When my son—and his godson—Harmon was murdered at age twenty-one in Florida in 1972, he consoled my wife and me.

Years later he graciously autographed books that Florence, an Algren collector, brought to him. Few autographs were as wild as the one in which he called me the worst poker player in the western hemisphere, although a great bugle "champeen." Or as hilarious as his autograph in our copy of de Beauvoir's *The Mandarins*, which she dedicated "to Nelson Algren" and to which he added, "on account of becuz he is mah ideel!" and then forged her signature.

Occasionally, when mime Marcel Marceau came to town, the three of us would wander around the city we all loved. One night at Schulien's Restaurant on Irving Park Road, Algren put on a Civil War trooper's hat, lifted an ancient pistol, and made believe he was dueling Marceau, who wore a Lincolnesque stovepipe hat and held a Colt pistol. We went to a Westside poolroom one day, and Marceau honored our trip by miming a pool shark in his show the night we attended.

I lost close touch with Algren around 1967, when he began teaching creative writing at the renowned University of Iowa Writer's Workshop—an impossible task, he claimed. "Reading is the only writing teacher there is. That and writing." He would reread Tolstoy's *War and Peace* and Dostoyevsky's *Notes from Underground* every couple of years. He also liked Kuprin and used his lines to

open *The Man with the Golden Arm*: "Do you understand, gentlemen, that all the horror is in just this—that there is no horror!"

Asked why he stuck to the west side of Chicago in his work, Algren once said, "A writer does well if in his whole lifetime he can tell the story of one street." About James T. Farrell's Chicago street-writing, Algren, ever acerbic with his competitors, told a radio audience, "You just don't like to see somebody lousing up your neighborhood." "He's a bastard," Farrell said to me at a *Time* party. "A brilliant bastard. I love his work." Even Algren's oldest friend, Jack Conroy, wasn't safe. In a review of a Conroy novel, Algren wrote that he thought it was redolent of his own work, and he asked if Conroy next was going to write about a legless man on a cart.

The love affair with Chicago began to fade in the early 1970s. Algren's close friend, my fellow photographer Stephen Deutch, remembers Algren's outrage that the Chicago Public Library had but one copy of *The Man with the Golden Arm*. Noting multiple copies of romance novels and the works of Saul Bellow, Algren stole the single copy of *Golden Arm* and gave it to Deutch. He often complained that the bookstores didn't carry his books, that the press generally treated him like a defaced Grant Park statue and couldn't wait to see him dead. When he fell through the ice one day at Miller's Beach, reporters rushed out to get the answer to their editors' query, "Was this a suicide attempt?"

His neighbors and haunts changed. The Poles and Slavs he knew either had died or moved to the suburbs, and the language of the people who replaced them was alien to him. After his death, when an admiring alderman managed to get part of Evergreen Street renamed Algren Street, another alderman got it

changed back. According to Dave Peltz, "He lost faith in himself and found it harder to write a whole sentence. And his racetrack addiction became too much." So in 1975, when *Esquire* offered him an advance to go to New Jersey to do a story on boxer Rubin "Hurricane" Carter, whom Algren believed had been railroaded into prison for a murder he didn't commit, Algren, then sixty-six, jumped at it.

"He felt rejected and neglected by the literary establishment," said Studs Terkel, "and he was right. The boys of academe really gave it to him. The Guggenheims never gave him a fellowship; his sardonic bitterness and irreverence rubbed a lot of big shots the wrong way. At least in the East he'd be surrounded by guys who knew his real worth, guys like Kurt Vonnegut, E. L. Doctorow, Peter Matthiessen, Betty Friedan, Irwin Shaw, James Jones's wife, Gloria. Matter of fact, when he died, he was getting a party ready for those people to celebrate finally getting inducted as a member of the distinguished American Academy of Arts and Letters."

Departing from the west side was the man who had written: "You can belong to New Orleans. You can belong to Boston or San Francisco. You might conceivably—however clandestinely—belong to Philadelphia. But you can't belong to Chicago any more than you can belong to a flying saucer called Los Angeles. For it isn't so much a city as it is a drafty hustler's junction in which to hustle awhile and move on out of the draft. . . ."

At his farewell house sale Florence bought his old desk for $300, the massive dark one on which some of *Golden Arm* and *Wild Side* had been written, the desk I had seen Algren and de Beauvoir lean against while drinking tea. When I went

to pick it up, my daughter Jane, then twenty-nine, went with me, and I photographed her and Algren together. The portrait shows a watery-eyed old man. "I need the money to move," he said of the sale.

In New Jersey he took up the cudgels for Carter, mostly a losing battle except that it brought him his last book, *The Devil's Stocking*, that would be published posthumously, a book that ends:

> The sound of a revolver's blast has faded across the years. The people who hear it are dead, jailed, or gone mad. The old faces fade: new faces take their place.
>
> All, all is changed.
> And everything remains the same.

I go to the movies and the Chicago smart aleck in the comedy is quoting Algren as if he just made it up:

> "Never play cards with a man named Doc."
> "Never eat at a place called Mom's."
> "Never sleep with a woman whose troubles are worse than your own. . . ."

Newsweek and *Sports Illustrated* covers plug several pitchers as "The Man with the Golden Arm." An anti-drug TV commercial shows a real monkey on a junkie's back . . . an image borrowed from *The Man with the Golden Arm*. My

January 20, 2007 issue of *Time* magazine runs a big spread on Seattle's new Olympic Sculpture Park. A banner of inch-and-a-half letters across the pages shrieks: "Walk on the Wild Side." Someone sends me a candy bar wrapper: Have a Taste on the Wild Side.

Filmmakers from Boston and Hollywood are thinking of centenary movies in 2009. They want to consider the pictures in this book. Our *Chicago Reader* does a story on me entitled: The Man with the Golden Eye. I blush.

My long gone pal Nelson Algren lives.

—Art Shay, Chicago and Deerfield, Illinois, January 2007

Nelson Algren's Books

Ernest Hemingway, who was ten years older then Algren, began reading and admiring him in the 1940s, when (modestly excluding himself) he called Algren the best writer in America after William Faulkner. In a fan letter to Algren, Hemingway hoped that he would write a long shelf of books. Many critics agreed with Hemingway's early enthusiastic appraisal and lauded the short stories collected in *The Neon Wilderness* and the urban social realism of *Never Come Morning*. To readers like these, Algren singlehandedly carried forward the tradition of the Proletarian Novel into the Post-War period. He was the heir apparent to John Dos Passos and Theodore Dreiser. *The Man with the Golden Arm*, which appeared the year I met him, was being received as the great American novel of the decade if not the century. Critics liked his "savage tenderness," his broad burlesques, his ability to look "at his Medusa without turning to stone." The *New Republic* and the *New York Times* praised him. Ralph Gleason, writing in *Rolling Stone*, likened his work to jazz and bebop and called him Bob Dylan's artistic father and the progenitor of Joseph (*Catch-22*) Heller and Ken (*One Flew over the Cuckoo's Nest*) Kesey. Mystery classicist Ross Macdonald said Algren was a continuing influence on his life.

Some of the heavy critics like Norman Podhoretz, Leslie Fiedler, and James Frakes couldn't abide Algren's prose-poem style. *Newsweek's* 1956 review of *A Walk on the Wild Side* accused him of nearly breaking into rhyme. Saul Maloff of the *New Republic* referred to Algren's prose as "overblown, elegiac, tremulous,

quivering, cadenced, or wistful celebratory nostalgia that used to be called prose-poetry." Of course, they had said the same kind of things about Walt Whitman in his day. Saul who?

Here's a short course in Algren's *oeuvre*.

Somebody in Boots (1935): A semi-autobiographical story of a wild young man's wanderings and adventures through Texas, Louisiana, and Chicago. Through hero Cass McKay we meet hoboes, con artists, prostitutes, crooks, prisoners. His descriptions of them are touched with the hard-nosed poetry of a promising writer. "He saw her once standing nude in a subdued blue light, her hair undone and transformed by a lamp's glow form its daytime yellow to a strange dark blue: it cascaded down her shoulders like a living blue torrent."

Never Come Morning (1942): The story of Bruno "Lefty" Bicek, a tough Westside Chicago street bum or Polish descent who dreams of becoming a pitcher, then a boxer. He heads a street gang, guiltily lets his friends gang-rape his girlfriend, murders someone, wins as a boxer, but is headed for the electric chair. "I knew I'd never get to be twenty-one anyhow," he says.

The Neon Wilderness (1946): Short stories, many about prostitutes. Published in its original edition by Doubleday, possibly the best introduction to his work. "The captain had bad dreams or who put the sodium amytal in the hill & hill?" is one of five stories in the book that either won an O. Henry Memorial Prize or were included in the anthology *Best American Short Stories*.

The Man with the Golden Arm (1949): The story of a Division Street poker dealer, Frankie Majcinek—"Frankie Machine"—whose masterful golden dealing arm also serves as the entry point for the insidious morphine habit picked up

during treatment for a wound in a wartime hospital. The habit makes Frankie a junkie with "a monkey on his back," a beast whose weight grows with his addiction. He also lives daily with the guilt of crippling his wife in an auto accident. Algren deals with love, anger, loyalty, chance.

Chicago: City on the Make (1952): A prose poem about Chicago's history and cocky stance in the world. It evolved from a long article Algren did for *Holiday* magazine in 1951.

A Walk on the Wild Side (1955): A novel, largely about the original hero of *Somebody in Boots*. Dove Linkhorn wanders the South and Southwest again, lighting in New Orleans.

Nelson Algren's Own Book of Lonesome Monsters (1962): A collection of short stories, including the work of other authors.

Conversations with Nelson Algren, with H. E. F. Donohue (1963): Algren is alternately humorous, sad, analytical, obtuse about his own life and works.

Who Lost an American? (1962): Algren at his hilarious, ironic best in the entrails of some of the world's great cities, including Chicago.

Notes from a Sea Diary (1965): More of the same but better and better, subtitled *Hemingway All the Way*. Calcutta: "I recall tossing a coin on to the dock and seeing a uniformed guard bearing down on the woman to take it from her."

The Last Carousel (1973): Short stories with titles like "Otto Preminger's Strange Suspenjers" and "The Mad Laundress of Dingdong-Daddyland." Algren presents wildly humerous satirical visions of how screwed up the world had become.

The Devil's Stocking (1983): His final book, a roman á clef about boxer Rubin

"Hurricane" Carter, was published in Germany then reissued in the United States two years after Algren's death.

In their first editions, Algren's books were published by a host of major publishers including Doubleday, Farrar Straus & Cudahy, Putnam's, and all the rest. But by 1983 every single one of Algren's books was out of print with the singular exception of his book-length prose poem *Chicago: City on the Make*, which had been published originally in 1951 by Doubleday and was being reissued by McGraw Hill and recently by the University of Chicago Press. The New York literary establishment hadn't liked my friend Nelson much after all, just as he'd always suspected. In 1984, a brilliant young editor named Dan Simon who had started a company named Four Walls Eight Windows, reissued *Never Come Morning*. He's reissued another Algren book every couple of years without fail. Now his company's called Seven Stories and you can find most of Algren's books under that imprint, including a critical edition of *The Man with the Golden Arm* that has a number of writings in it from a new generation of folks with Algren on their minds, and a photo essay by yours truly.

—A.S. Chicago, January 2007

Chicago's Nelson Algren

Nelson Algren at his trusty old Royal in 1949 proofreading an early version of *A Walk on the Wild Side*. Beyond him, across the street, is the nondescript hangout bar he used as a model for the Tug 'n' Maul in *The Man with the Golden Arm*. On his bookshelf can be seen Ben Hecht's *Eric Dorn* for which Nelson wrote a reprint introduction in which he might have been writing about his own work: "Hecht's people come alive when he looks at the city through their eyes."

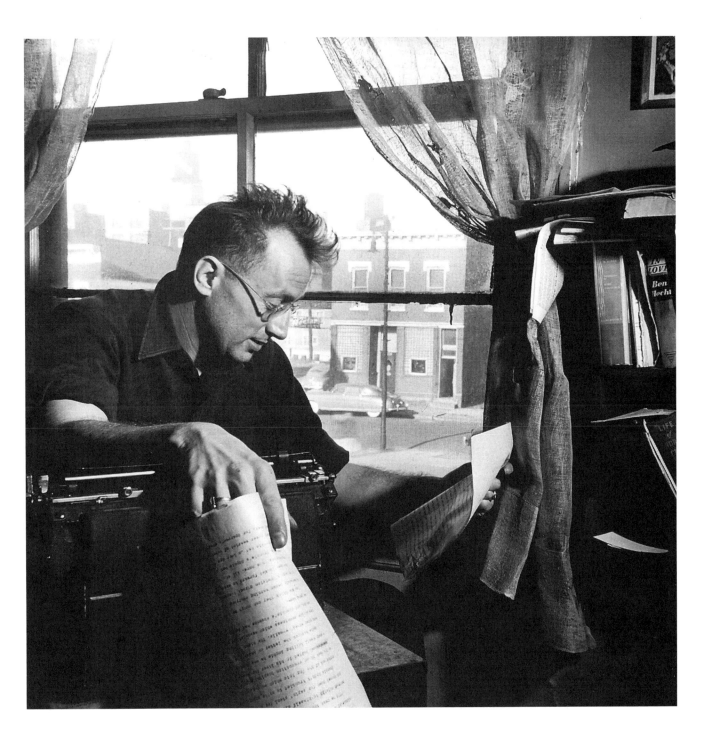

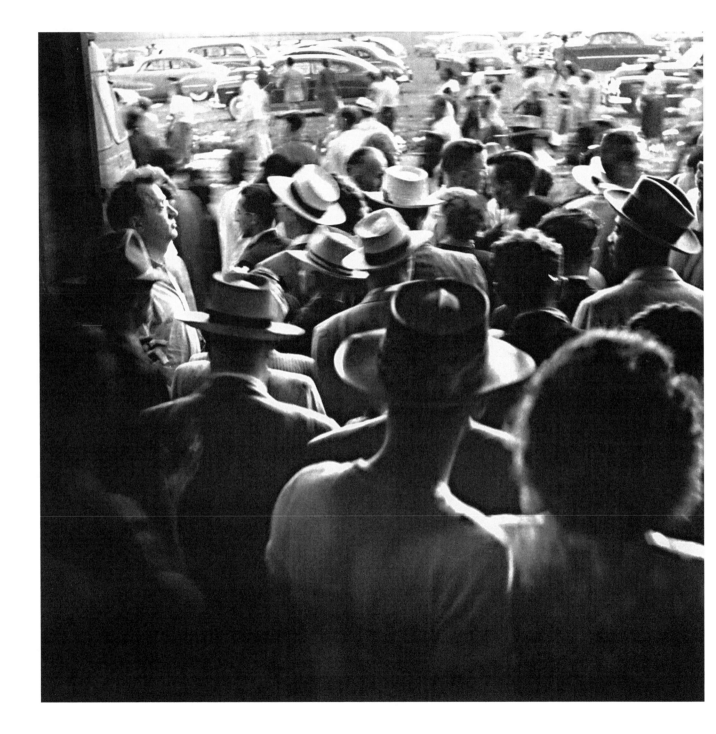

Algren studies his fellow Chicago White Sox fans as they leave Comiskey Park for their Forties cars after yet another loss.

Combining business with pleasure, Algren first manages to pick three losers at the Hawthorne track, then (small picture) mingles with the crowd for his one and only *Sports Illustrated* assignment—working with me covering "Stoopers"—the bettors who salvage thrown-away betting tickets for possible overlooked winners.

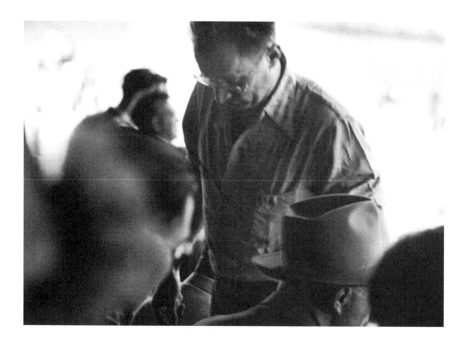

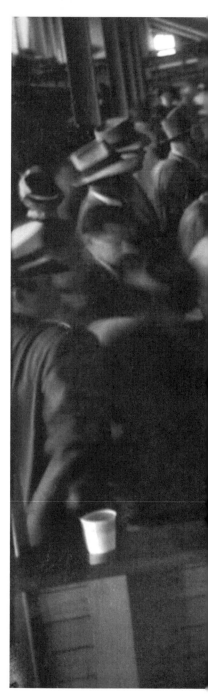

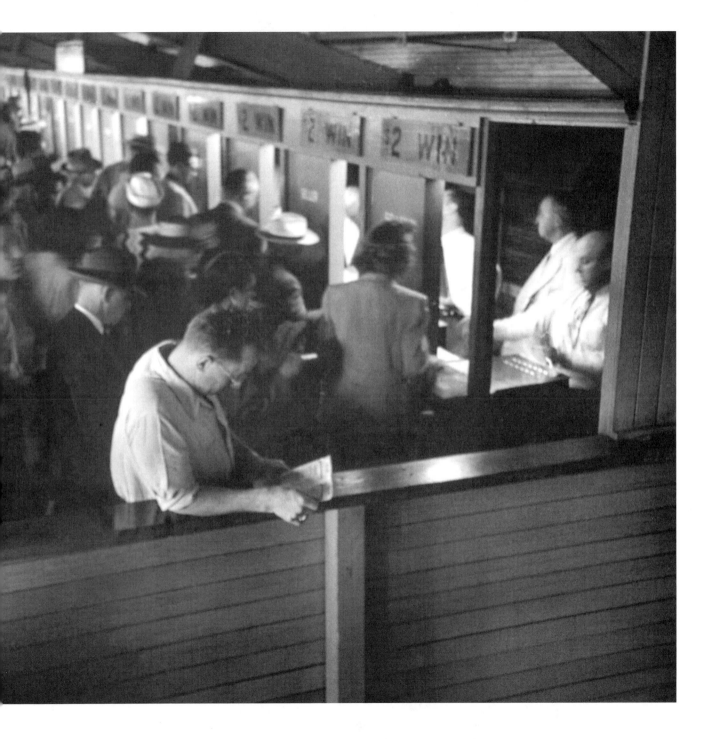

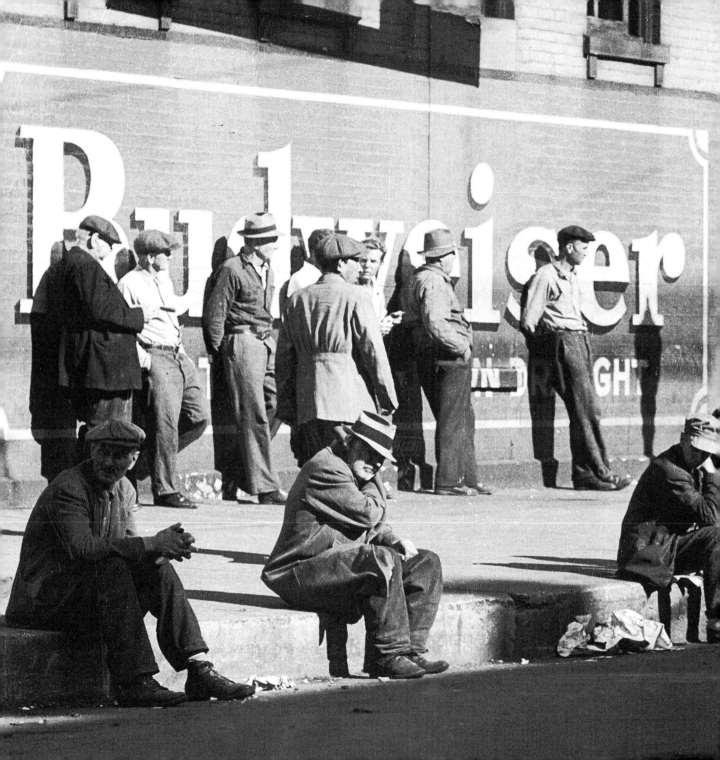

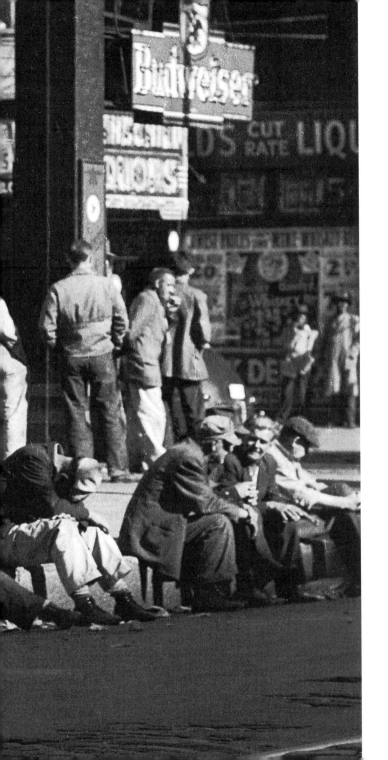

In the local middle of his city's rusty heart—his love-hate lady with a broken nose—Nelson showed me Baudelaire's "infamous city" and Dostoevsky's insignificant "specks of humanity" getting up from "all night and all night and all night" as Nelson put it, to feel the warmth of a sun that's been to Russia while we slept. They congregated in Skid Row from alleys where they awoke looking at the cats. They came here for the first drink or handout of the day from the urine-smelling flop houses and all-night bars, preachy missions and stale-food restaurants of a grungy neighborhood Row soon to be plowed under for high-rent office space. These bums were largely veterans of WWII and Korea with a sprinkling of WWI derelicts, living on meager disability, social security checks, begging and alcohol. All of which fed their hopes of someday living again, the way they did in uniform. Losers mostly, smelling of piss and alcohol. "Budweiser wasted that sign on them," Nelson said. "No one gotta tell em to drink beer."

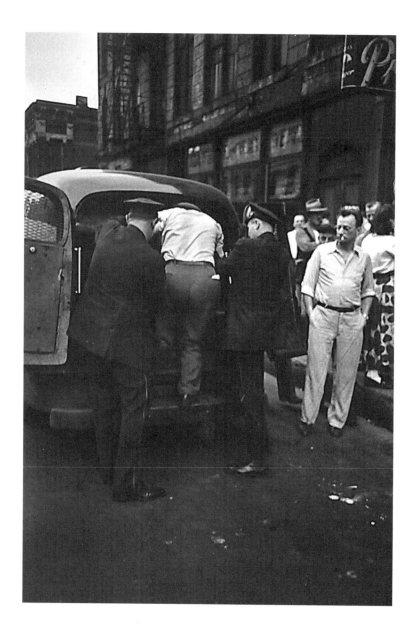

Nelson watches the cops haul away a boisterous drunk on Madison Street, then, in his favorite all night restaurant on Clark Street, witnesses a sleeping drunk being awakened and thrown out. He taught Simone de Beauvoir how to cheat such a restaurant. "You pull two tickets from the gong machine when you go in, so the bong sound sounds like one, then you eat your main meal on one ticket but get a cup of coffee on the other, so you just pay for the coffee and eat the other stuff free." Simone loved learning to steal and couldn't wait to tell an admiring Sartre, Nelson said proudly.

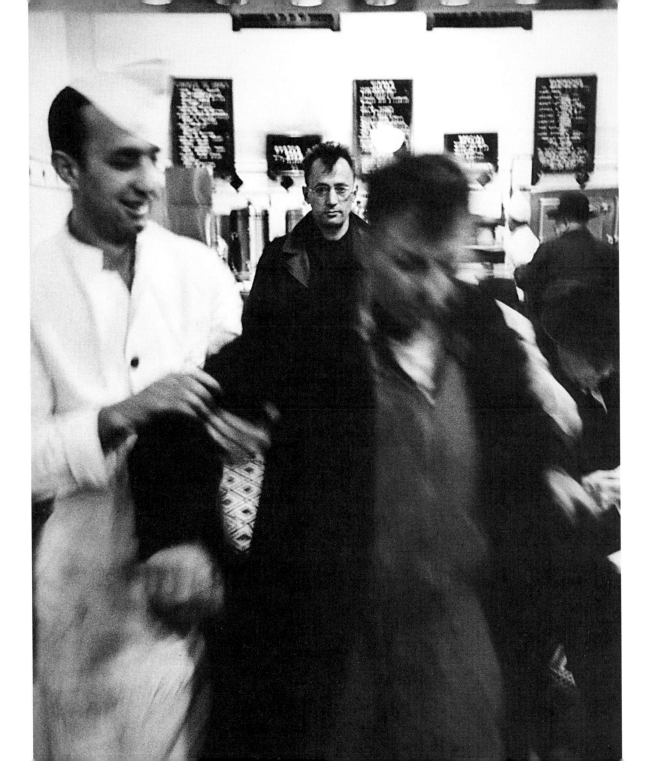

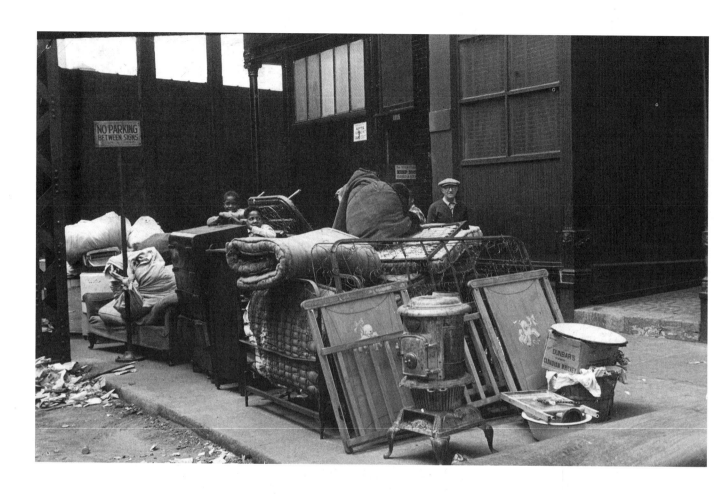

On the used $4 Schwinn bike he used to replace his stolen eight buck model, Nelson explored the back alleys of the side streets on either side of his beloved Division Street.

Among the saddest of all neighborhood sights Nelson saw while coursing his neighborhood, was the eviction of a family from their apartment. Nonpayment of rent for five months usually brought the sheriff's eviction crew, heartless as landlords, to move a family's possessions to the sidewalk.

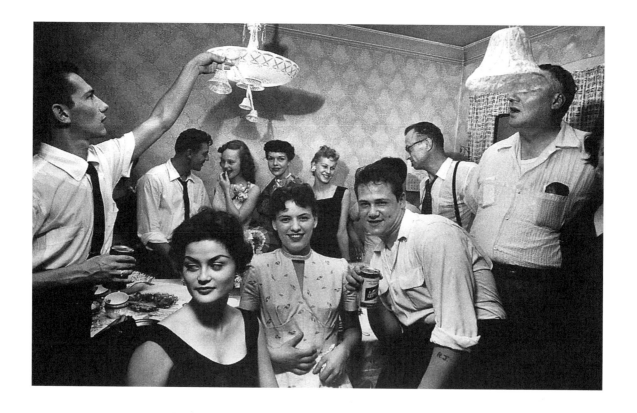

Nelson liked informal gatherings of his second generation Wicker Park friends. These included some ex-jailbirds, on and off junkies, and straight pals, including a mother-son incestuous couple who hid from the camera. He was an avid listener and eventual adapter of some of their lives into his fiction. He loved his real-life models and they loved him. They treated Nelson and me as amusing squares who had somehow fallen into strange habits—writing and photography.

At 2727 W. Lawrence, where she lived for long years, Nelson's mother, Goldie, "who gave me some of her German toughness," he boasted, often served us Sunday breakfast. I once took Nelson to lunch at my mother's fine Far Rockaway apartment, and he called it a tie—whether his or my mother was the lousier cook. Goldie was in his mind when he wrote, "Never eat at a place called Mom's."

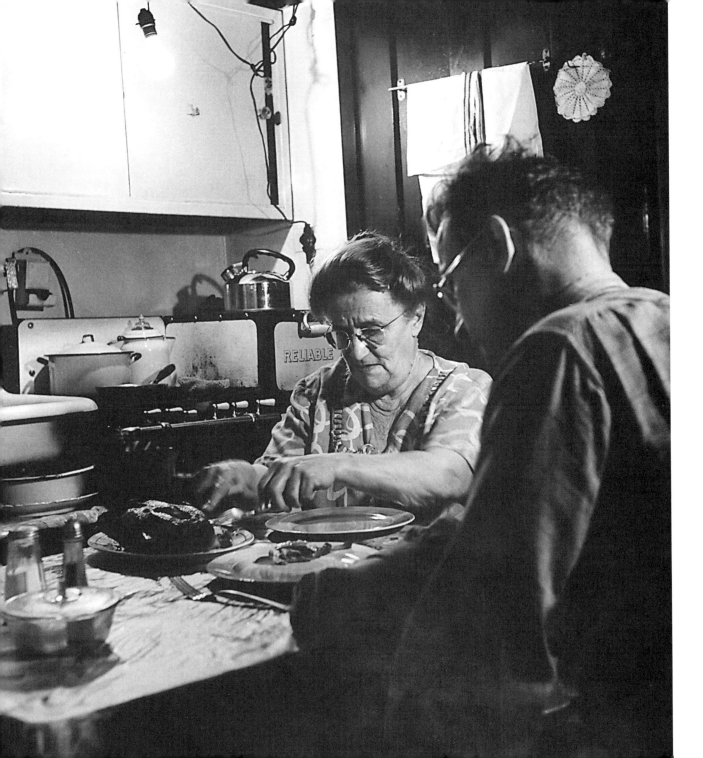

You never know how good it can be till you're found out for yourself how bad it can get.

Nelson Algren

PHOTOGRAPH BY
Arthur Shay

My archivist, Erica DeGlopper, discovered a dozen prints on which Algren had scrawled captions. My favorite: "You never know how good it can be until you've found out for yourself how bad it can get." Nelson scrawled that caption on the back of this portrait of him. He stood in the doorway of the bar in which he had spent the afternoon talking to Milwaukee Avenue friends who knew the originals of some of his fictional characters.

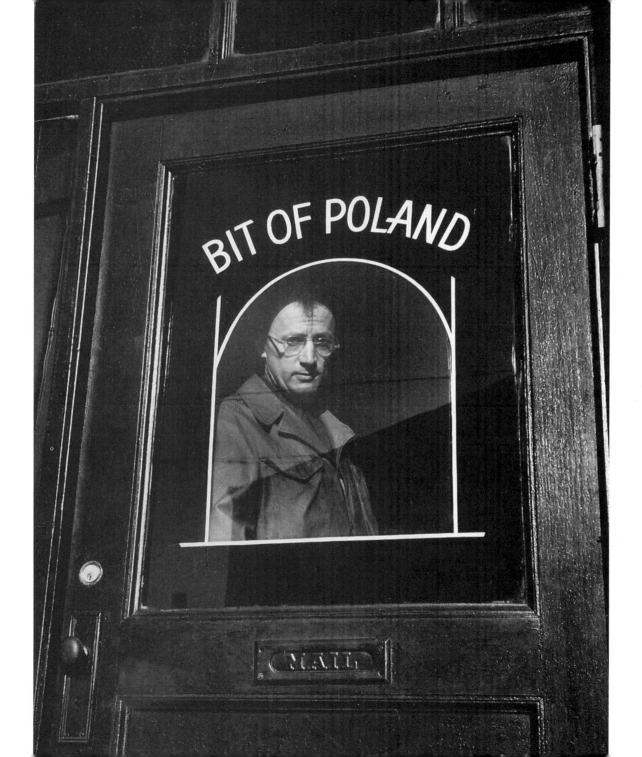

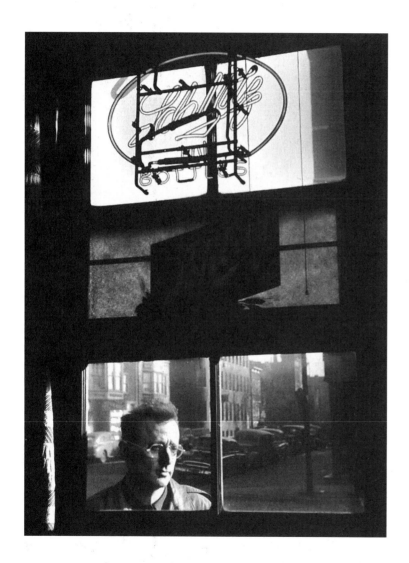

Nelson loved the cheery, smelly, argumentative atmosphere of the neighborhood bars to which his fictional characters gravitated in their real lives.

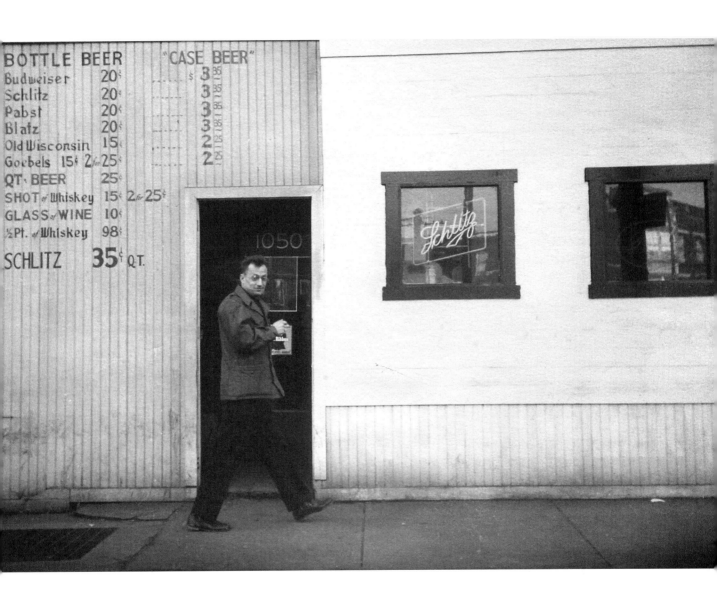

19

On a cold winter night just before he won the very first National Book Award in New York, Nelson pauses at the epicenter of his fictional—and diurnal—world at the intersection of Damen and Division. He liked the sudden flashes of light from the short circuits of overhead bus wiring. I tried to position one of these flares to make it appear its provenance was Nelson's—to me— fantastic eye. It always reminds me of my favorite line from Shakespeare: "The poet's eye in fine frenzy rolling from earth to heaven and back to earth again." My friend, along with all his astral achievements and woes, was nothing if not down-to-earth.

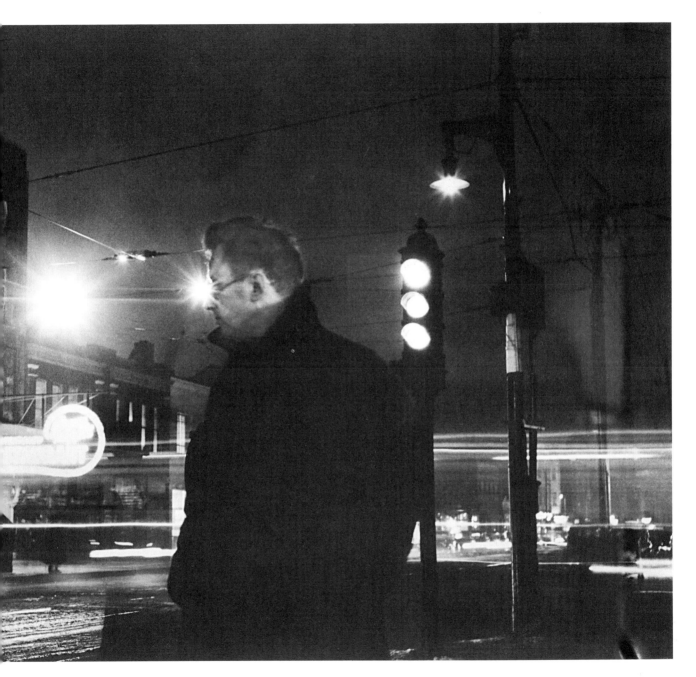

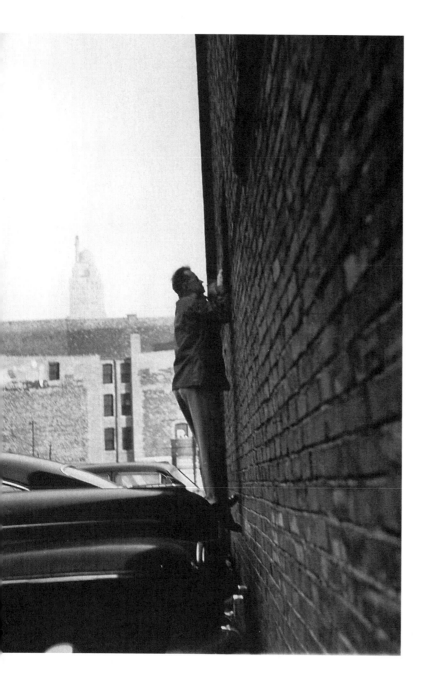

Nelson had written about the last remaining gallows Chicago had preserved in this Ontario Street storeroom. A convicted murderer named Tommy O'Connor had escaped the hangman the night before his necktie party and never again surfaced. It was more than half a century from both crimes when Nelson peered in.

Not far away, in a cold Division Street twilight, Nelson examines his literary domain before we repaired to the historic kosher delicatessen across the street that stood there into the Sixties. Hot tea in a glass with a mammoth corned beef on rye were his favorites here, though on his own, and with Simone, he preferred a black-owned Lake Street rib joint that insisted you pay up front.

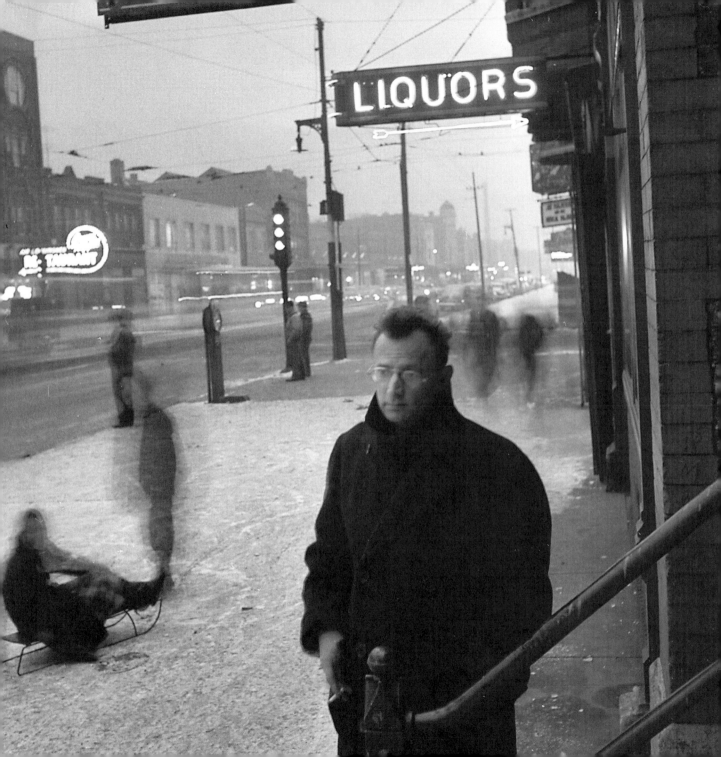

Algren was addicted to poker. Here, in a Division Street basement joint he is dealt to by the original "Man with the Golden Arm"—a friend of his named Hackett. A masterful poker dealer, Hackett was always trying to escape his heroin habit. Nelson abominated the way Sinatra played Hackett in the "Arm" movie, especially "the way he kicked heroin as if it were a summer cold." Nelson would have much preferred Marlon Brando in the part.

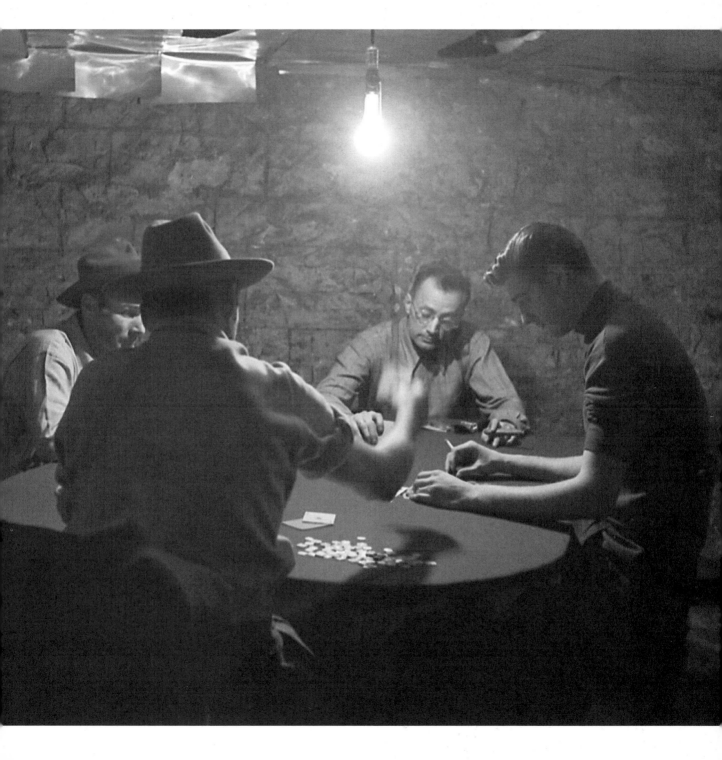

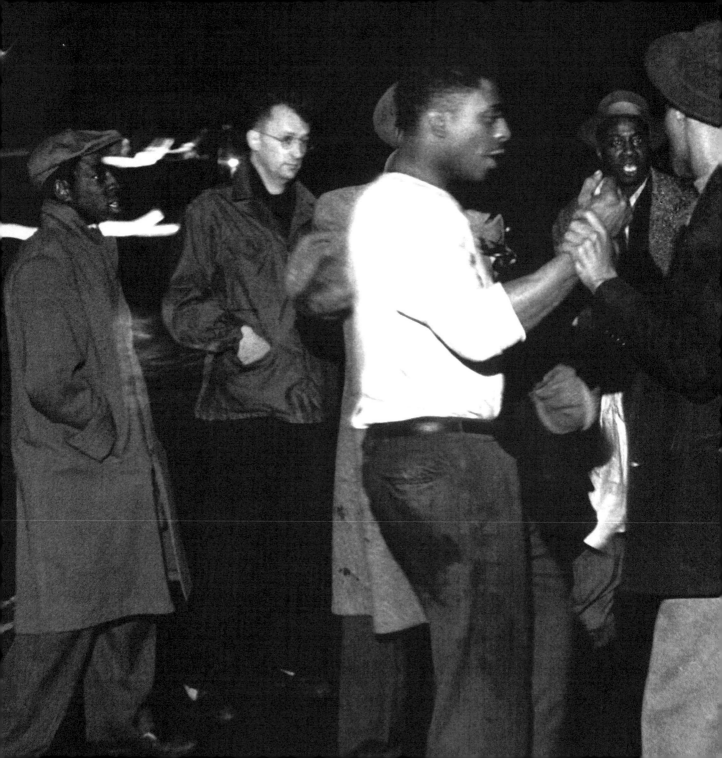

The Chicago Street has always been the poor
man's theater and home away from home—if
any—agreeing with his Frenchy's description of
her own and Jean-Paul Sartre's *arrondisse-
ment* and the Paris of Marcel Marceau, and
long ago, the Paris of Baudelaire, one of Nel-
son's strong influences. Wearing his three buck
Salvation Army jacket, Nelson wandered the
purlieus of Division and Milwaukee Avenue, as
I followed with Leica at the ready but half-hid-
den under my old 8th Air Force flight jacket.

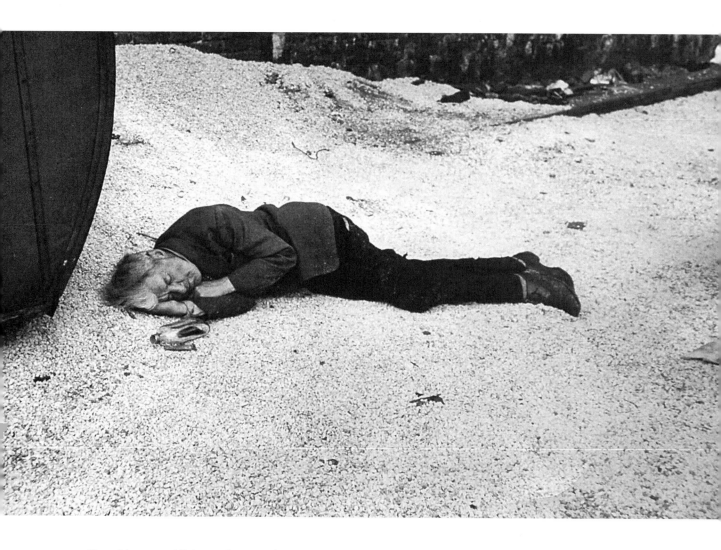

The cold stones of Chicago often provide a resting place for some of its street people.

Nelson liked the idea that the little dog seemed to elicit more interest on Clark Street than the dying drunk a few feet away. De Beauvoir, Nelson said, "looked past the inhumanity when I showed her this picture. She noticed that the guy had stigmata on his wrist, 'as if he had come down from the cross.'"

When my picture of "The Pause that Refreshes" appeared in a magazine, a Coca-Cola PR man tried to buy the negative for $500. Said he, "This is not the image we want to project of our product consumer." Nelson wanted me to do a picture of someone else urinating in a coke bottle. "It ain't enough that you buy their product," he said, "You gotta look like a Republican who could really afford champagne." Nelson loved the street carnivals on the west side. They featured performers like Sam the Swordsman.

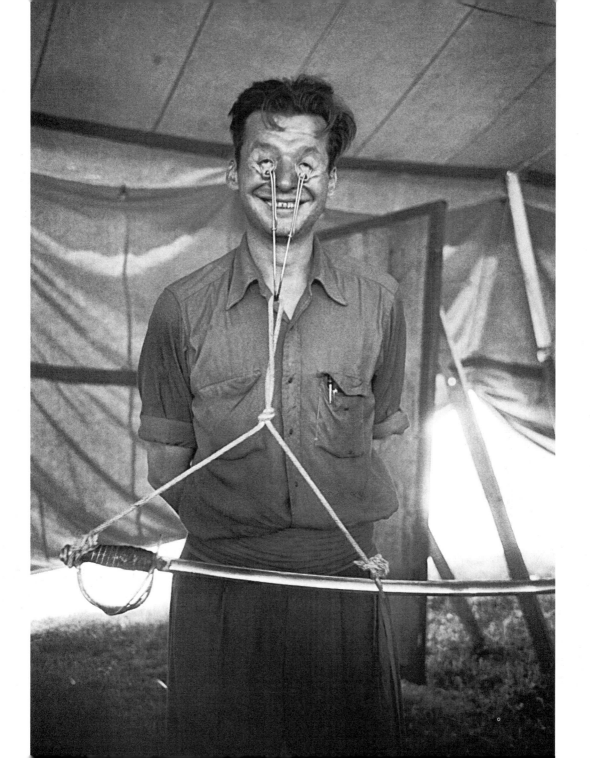

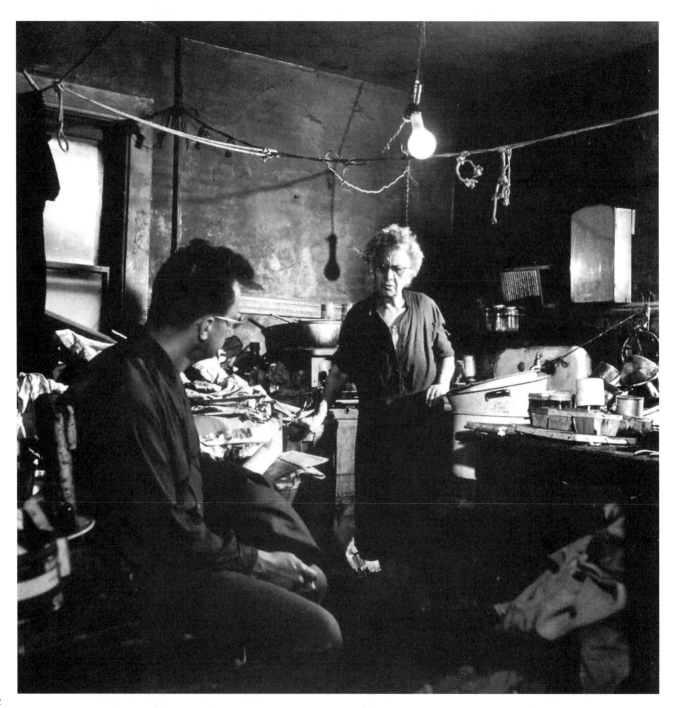

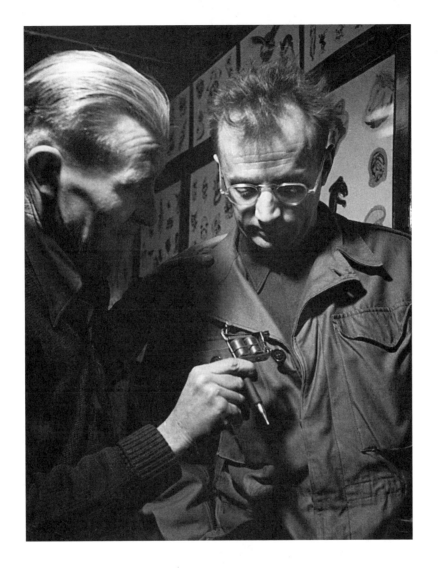

Sally, a former hooker then madam, outlived all of her girls. Nelson could listen to her speaking about "the life" long past for hours. She was a good source for the whores with hearts of gold who appeared in *Never Come Morning*.

On State Street he found a self-described healed heroin junkie who now made a good living doing tattoos. "I will never know why my most popular image is a sacred heart with a dagger running through it." Nelson recalled, "He once did a priest who asked for a tattoo on his shoulder of, so he said, himself as a ten year old acolyte."

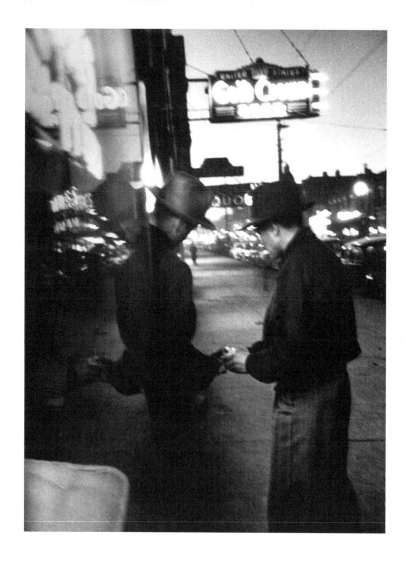

Nelson's interest in drugs and junkies came mainly while working on *The Man with the Golden Arm*. His protagonist, Frankie Machine, based on a St. Louis friend of Nelson's named Hackett, was a heroin addict desperately trying to cure himself while becoming one of the best poker dealers in the country. It made Nelson uncomfortable to be photographed watching Hackett demonstrate shooting up. The dealer and user shown in the Division Street doorway let me shoot their picture as long as I kept the faces unidentifiable. I asked the man on the left, Yellow Jack by name, how heroin made him feel. He said (approximately), "If you put seven beautiful movie stars naked on seven beds—like Ann Sheridan, Joan Crawford, Rita Hayworth, and them—and put one ampule of heroin on the eighth bed, you'd see this nigger crawling over them seven girls to get at that fuckin ampule. That's how it make you feel Mr. Picture Man."

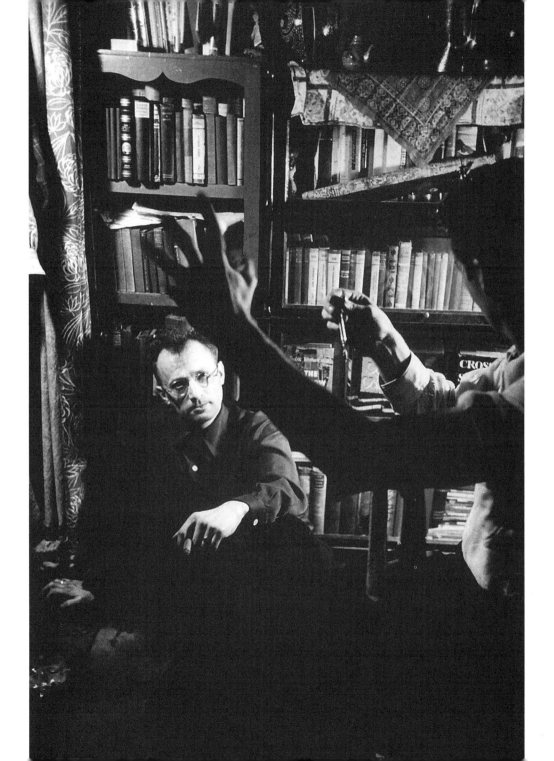

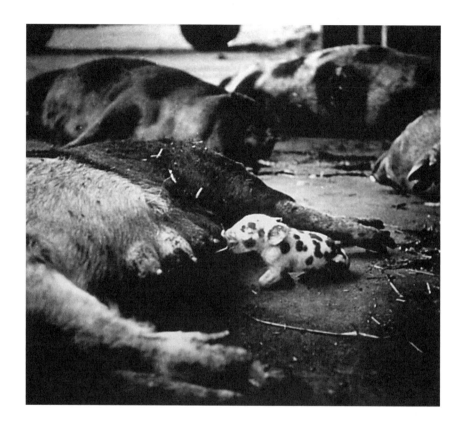

A Sunday supplement, *This Week*, with a circulation of many millions, asked me to illustrate their story of the crowded, abusive way Midwestern animals were packed on their way to slaughter in the historic Chicago Stockyards—the classic "Jungle" killing ground of yore. The baby Spotted Poland had futilely tried to get milk from his dead mother (top of picture), then feebly worked his thirsty way down the teats of other dead, pregnant sows who had also been crushed in transit. The little guy, I learned, died of thirst two days later. Our story helped get the Department of Agriculture off its FEMA-like ass and shipping procedures improved. Despite this amelioration, The Stockyards were gradually done in by geography and the big cattle auctions and slaughterhouses moved to Kansas City (right) where I photographed this one for *Ebony Magazine*.

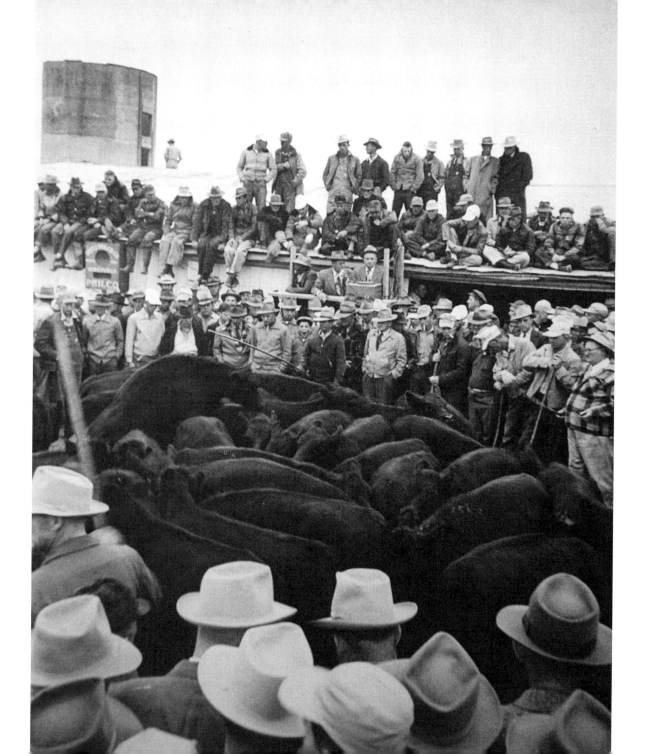

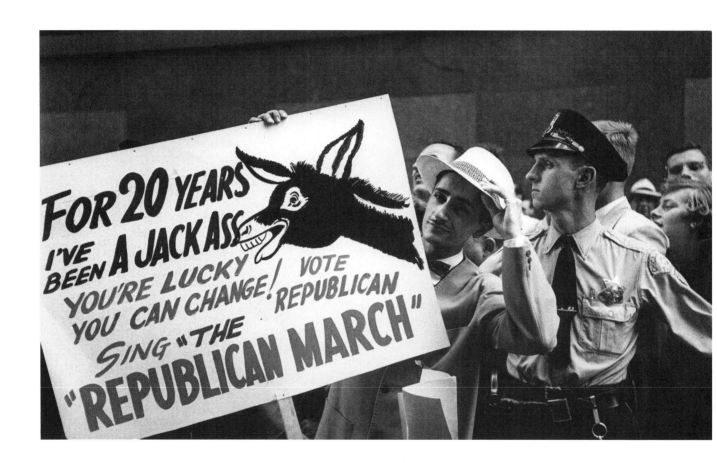

Nelson was tempted to vote for his old commander in chief, Ike. But Nelson knew and liked Adlai Stevenson ever since they had bumped into each other in the Gold Coast doorway of an unknowingly-shared lady friend. "I was first," Nelson claimed Adlai quipped. "So why did she send for me?" Nelson swore he answered.

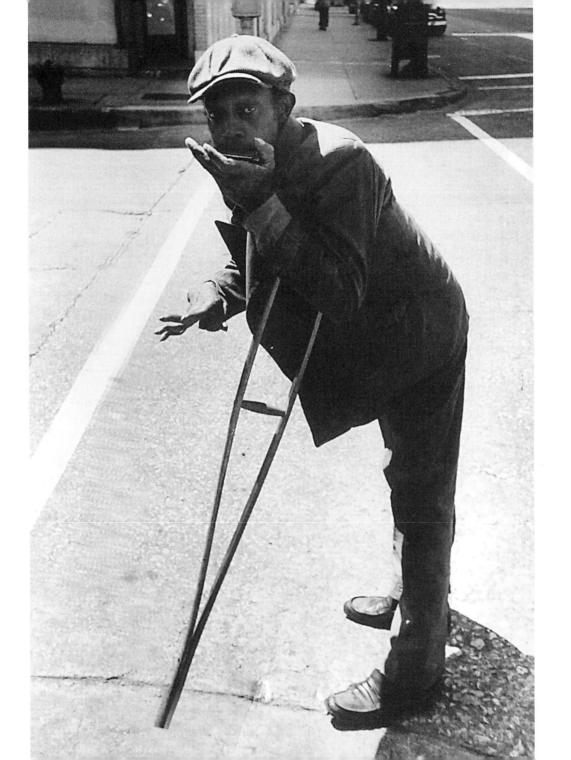

Chicago is a town of real musicians and mock musicians, like the arthritic harmonica player and the first Mayor Richard Daley campaigning amongst the Hispanics in 1959.

On their third night in Chicago, the Democratic conventioneers in 1968 Chicago knew they were in trouble nominating Hubert Humphrey while the police abused the Hippies and the National Guard prevented delegates from entering the Hilton. Playwright David Mamet covered this scene as a young reporter for a Hippie paper. He now owns a large print of this picture and has it hanging over his Santa Monica office desk. In a fan letter he wrote: "Art—this picture sums up that whole terrible time for me."

Note: In October '06, when Mamet was in Chicago to accept a literary award from the Chicago Public Library, he told me that seeing my name on the "Welcome Democrats" picture every morning impelled him to name a character in his crime series after me. He didn't think I'd mind.

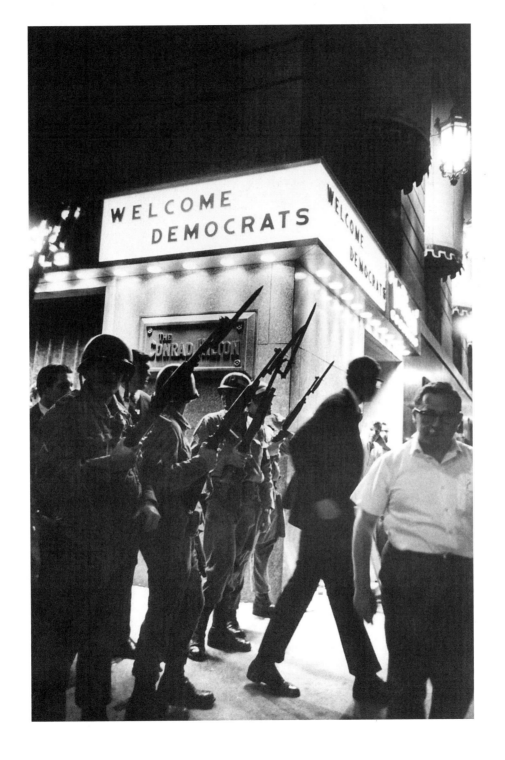

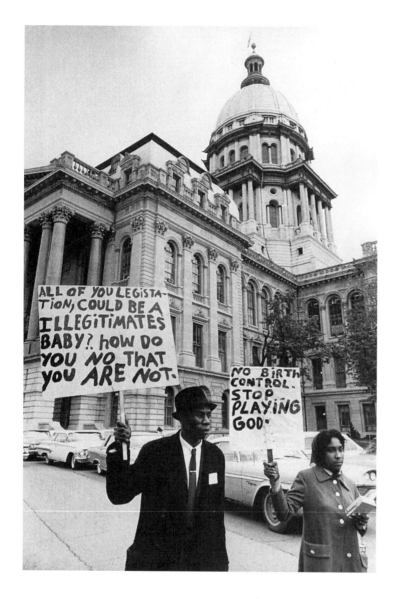

Racial hate and illiteracy often go together in Illinois.

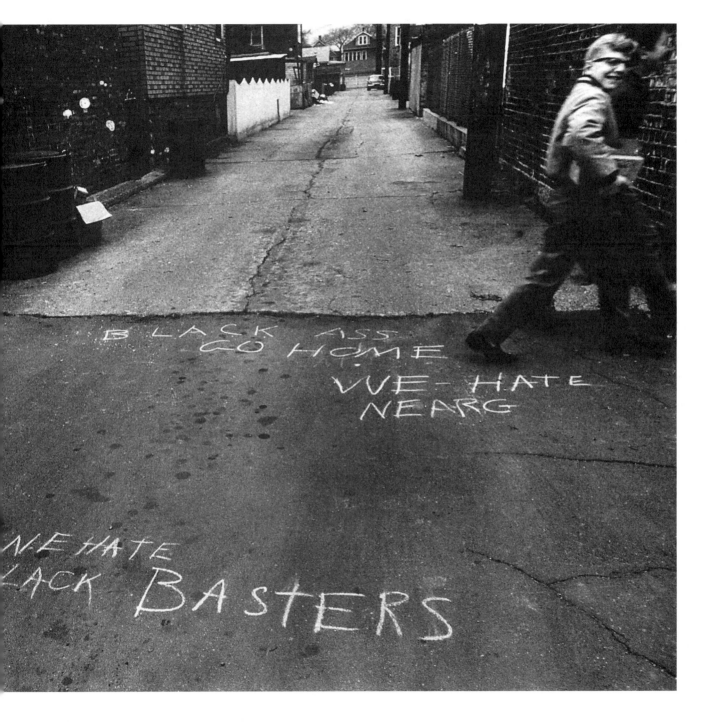

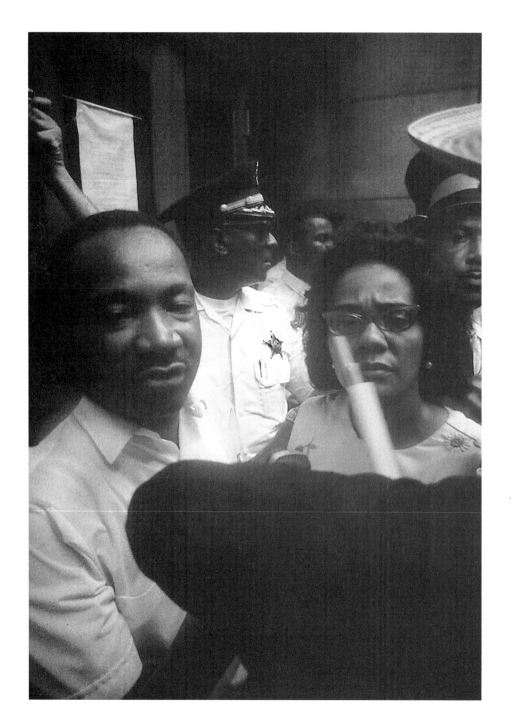

Shortly before his murder in Memphis, Dr. Martin Luther King and his wife Coretta posted their demands for human rights on the door of Chicago's City Hall (behind them), just as the original Martin Luther, shortly before his excommunication, had posted his 95 demands for reformation of the Catholic Church on the door of Castle Church in Wittenberg, Germany in 1517.

At right, a son of religious leader Elijah Muhammad sleeps through a concert by a choir of Black Muslim nuns.

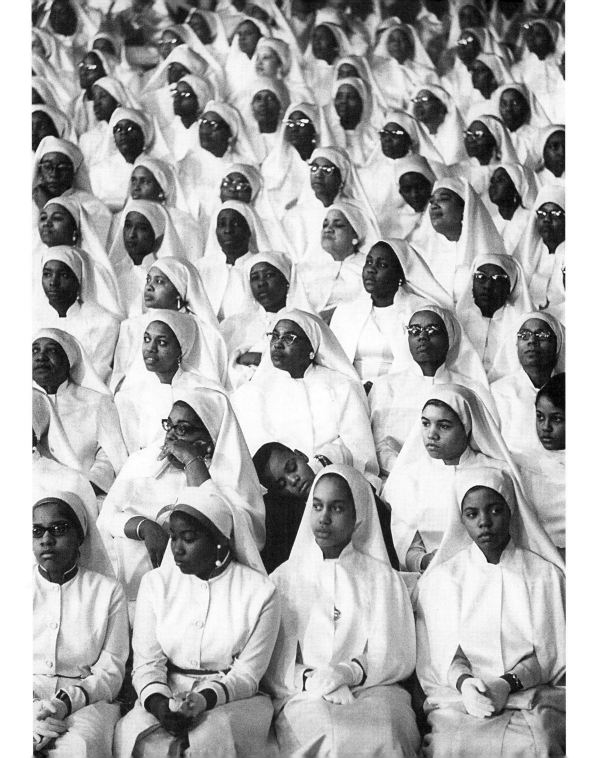

47

The best free food and showers in Chicago was—and still is—served at the venerable Pacific Garden Mission on south State Street. "It ain't too bad," Nelson said, "if you feel guilty anyway and don't start wonderin' who asked Jesus to die for your sins."

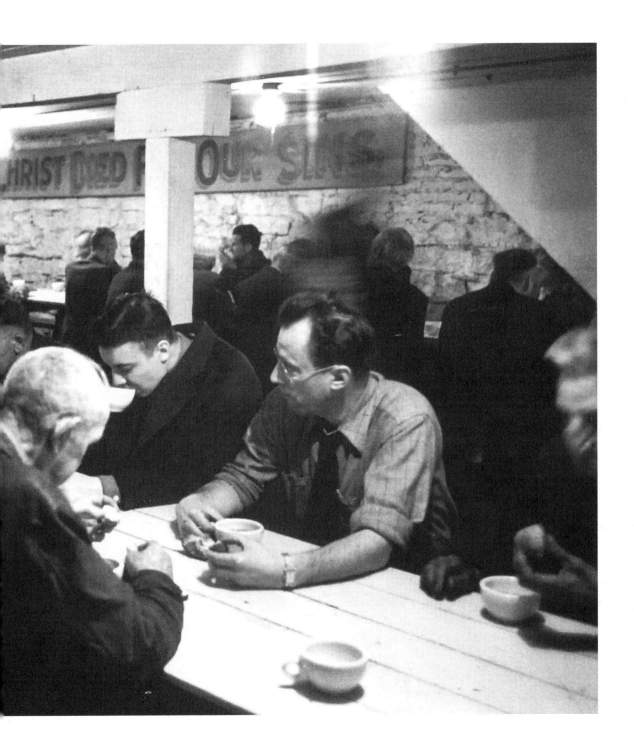

49

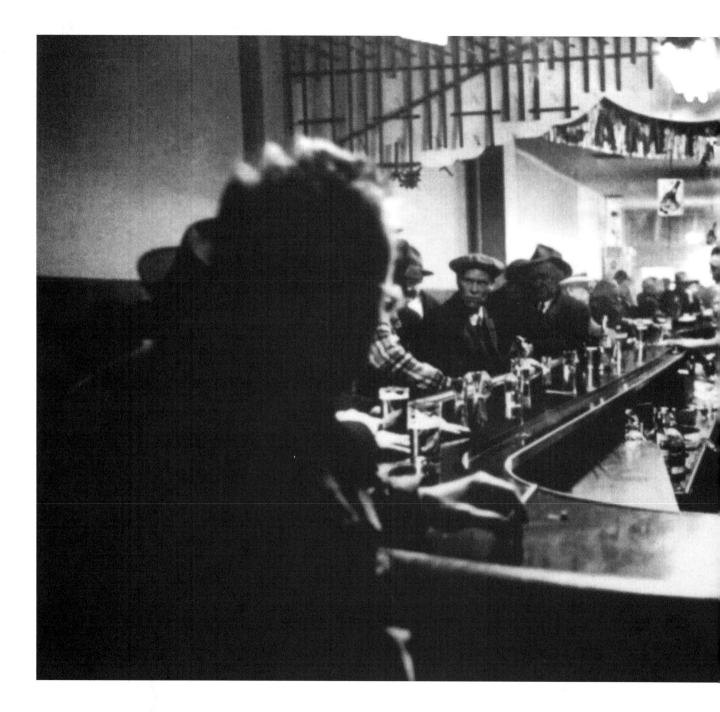

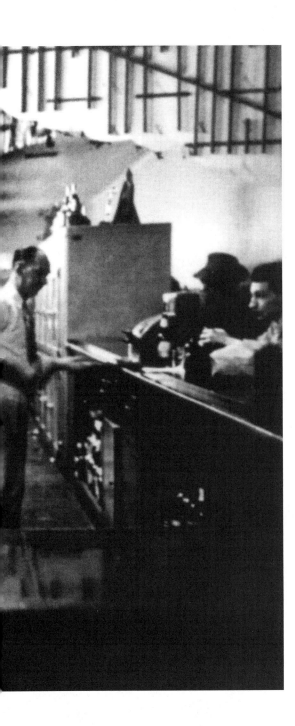

Nelson and I wandered into this grungy bar while working on the *Holiday* magazine story that became the book *City on the Make*. When Nelson captioned a near frame of this one to (approximately) suggest that the people at the bar—the guys on the left—were "Here and there bummies of the night . . ." one of them sued Curtis Publishing for $30,000. And lost. I was the star witness and was asked in cross-examination why I used a hidden camera and shot from a phone booth. I replied, "It was cold outside." That broke up the court, the judge, and the case.

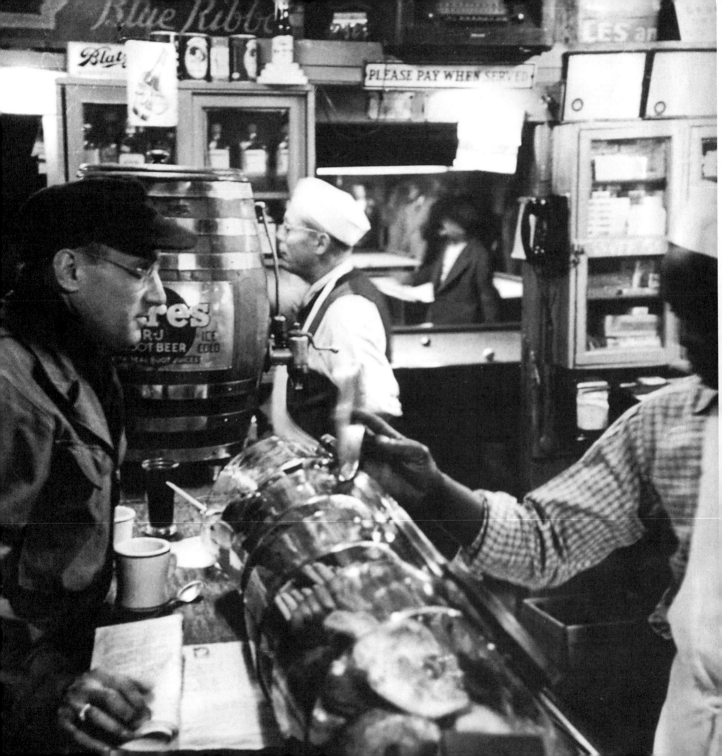

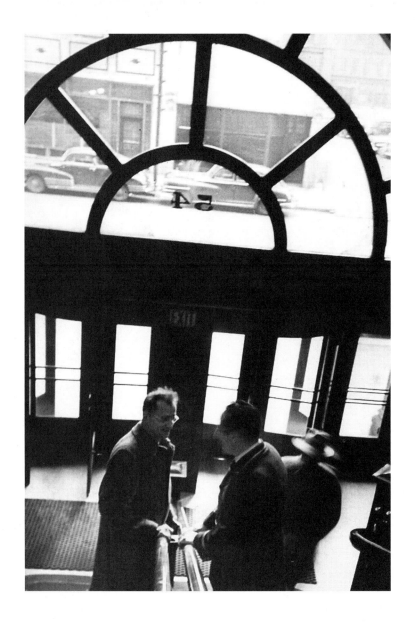

Nelson was proud of having worked in both these places. When he was a kid he worked at that backroom pool table on Ashland Avenue. After WWII he worked with the Chicago Board of Health in this Loop building, helping poor patients fill out applications for medical care long before Medicare.

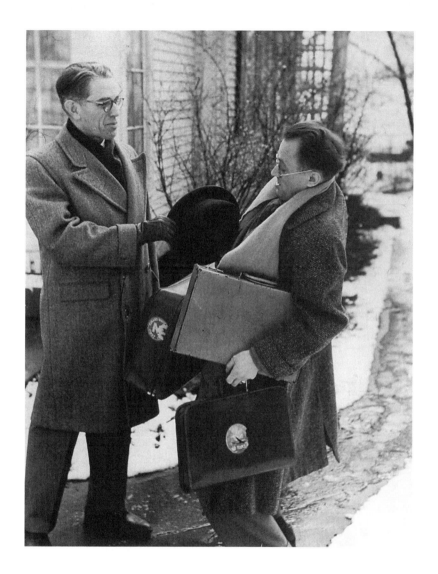

Nelson's $15,000 cottage on a backwater patch of Lake Michigan at Miller's Beach, Indiana, was where he and de Beauvoir spent some idyllic, then terrible days.

At serious financial odds with Doubleday, Nelson defanged its editor in chief Ken McCormick (above) just before negotiations for "City on the Make," symbolically acting the subservient bellhop by getting McCormick's gear out of my car. "Marceau woulda done it better," he said later, "but I made my fuckin' point."

On south State Street, near a congeries of tattoo parlors and strip shows, Nelson loved to seek out nickel-a-show hand cranked movies, many of them made in Chicago in the early years of the 20th century. "Chaplin ranks with Edison and Einstein as geniuses of the age," Nelson averred.

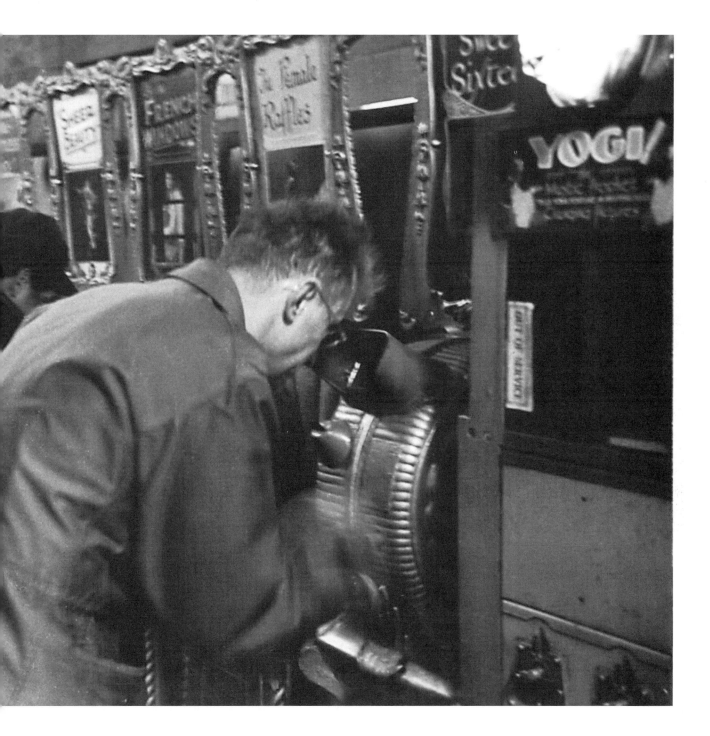

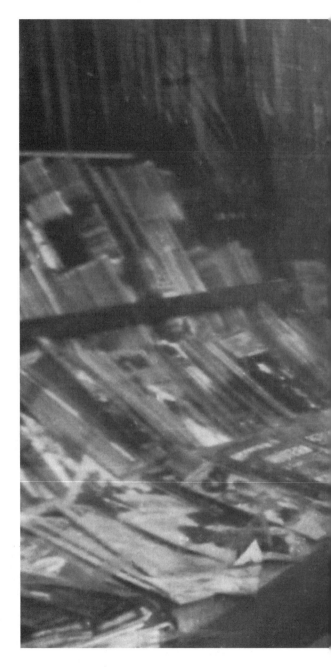

An imported Greek crystal ball caught Nelson's eye on Halsted Street in Greek Town.

On Ashland he checked the many Polish publications that arrived from Warsaw. The Polish cultural association had attacked *Never Come Morning* and *The Man with the Golden Arm* because they thought his depiction of Polish-Americans was unfair.

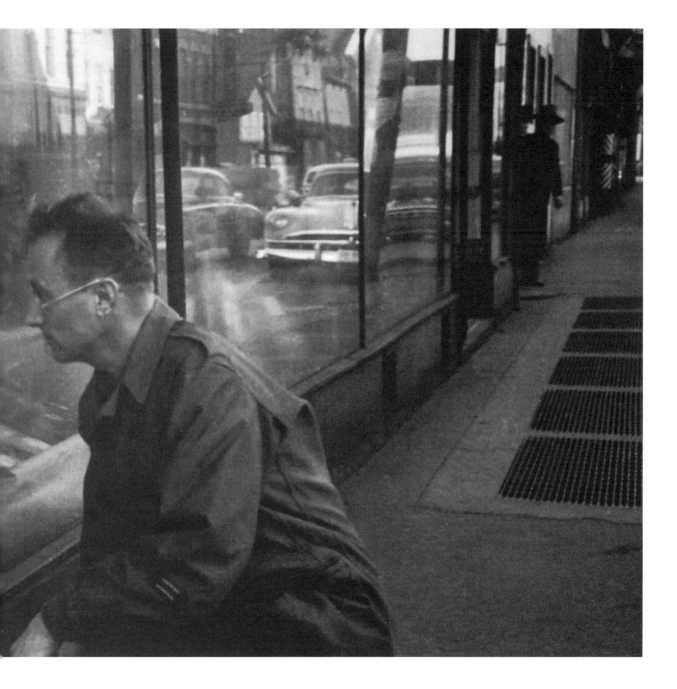

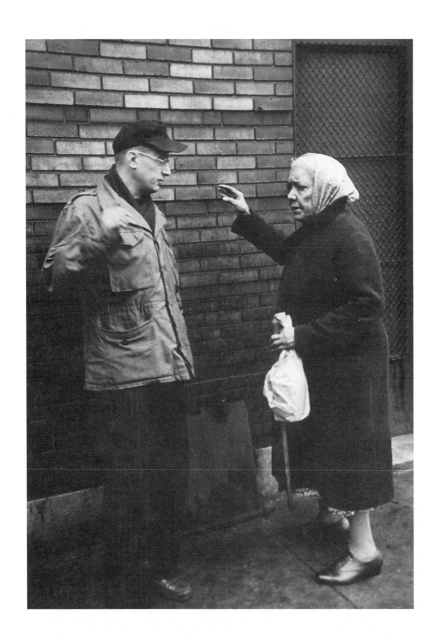

Whenever we walked through Nelson's neighborhood, Ashland Avenue here, he always found time to listen to his neighbors.

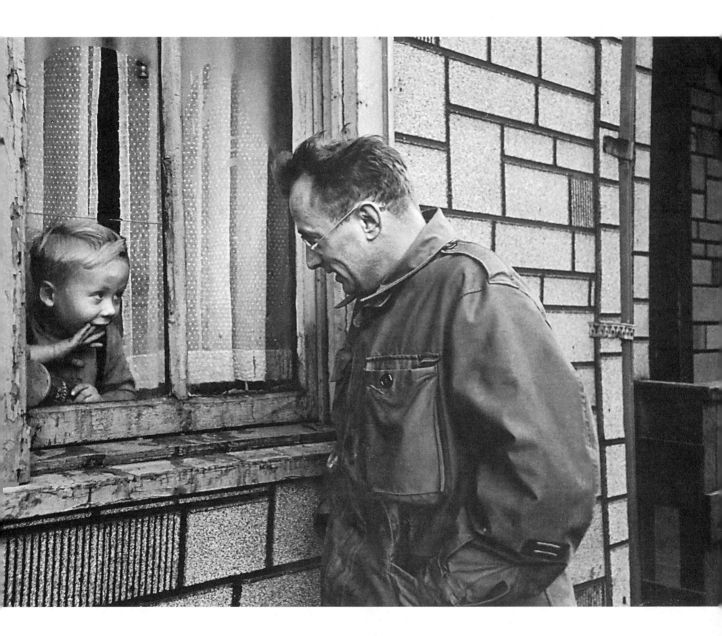

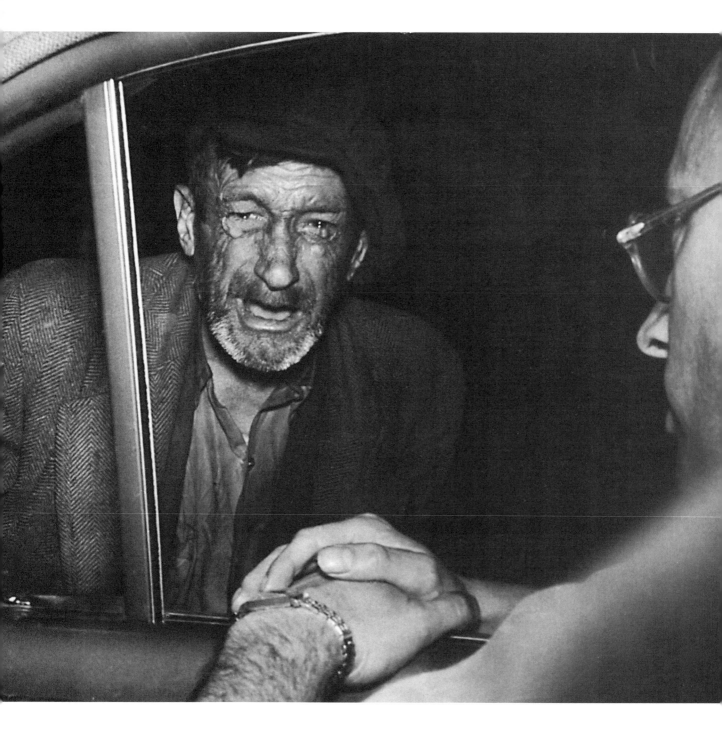

The never-ceasing alcoholic beggary of Chicago bums especially at night, often resulted in bits of imagined history in trade for our quarters and dimes. "You know that flag-raising at Hiroshima?" this guy averred. "I did it despite all the radioactivity around me." That was worth a buck.

Chicago, unlike New York, is a town in which directions are freely offered. David Mamet says he likes my pictures because they are like the characters who tap you on the elbow to offer directions, advice, or conversation.

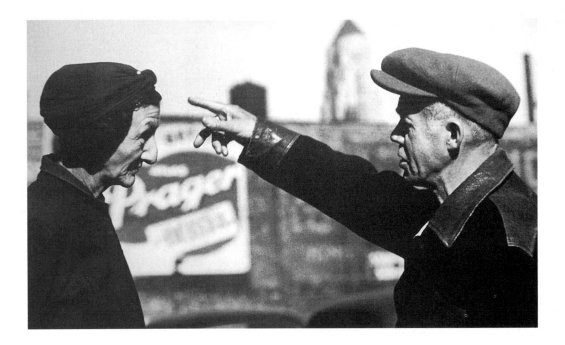

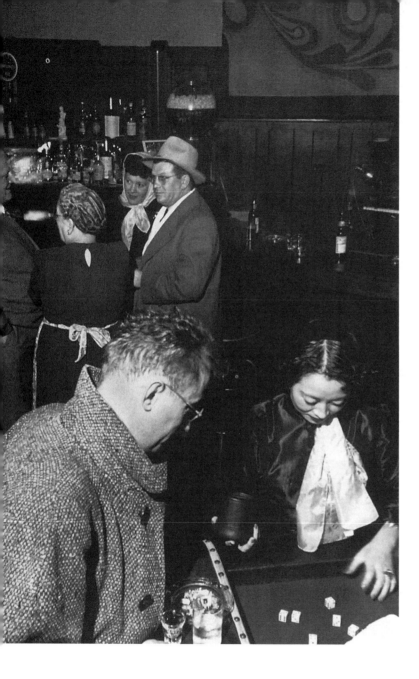
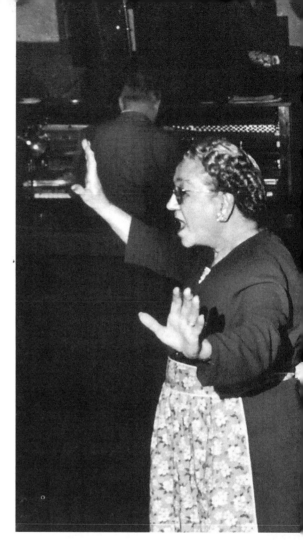

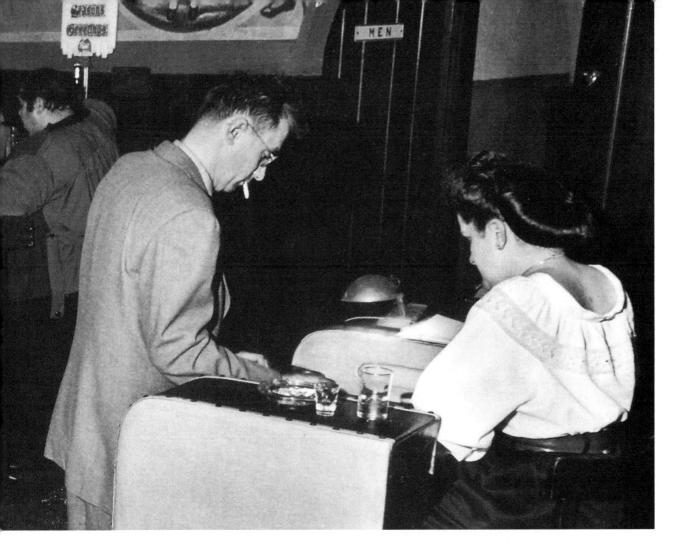

Algren plays a bar game with dice while listening to Flo, the joint's singer for the past 50 years.

His opponent in the dice game on the opposite page is none other than Mari Sabusawa, a long-time girlfriend of his, who often did the housecleaning at his cottage at Miller's Beach after spending the night there. I bumped into Mari one night in the Loop and she asked me what I was doing. I told her by sheer chance I was covering the Asian-American banquet and conference at the Hilton for *Time* magazine that very evening. She said, "Oh I wanted to go, but couldn't get a ticket." I gave her my press card and by the time I got in, Mari was sitting next to James Michener! A year later they were married, and a short time after that Mari was running the $30 million writer-award program the late Michener had established. I didn't find out about this until it was too late, but had the cards fallen another way I'm sure I could have persuaded her to help Nelson through a tough financial patch.

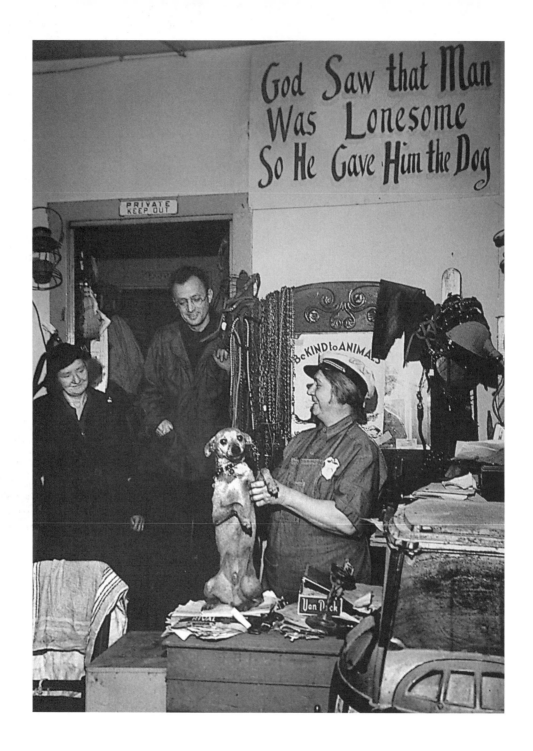

Nelson had stumbled on a WWII veteran who used to buy and sell homeless dogs—often from the kindly Dog Lady Viola Larsen, here trying to pitch dog ownership to Algren, who preferred cats. Algren had incorporated the personna of the GI dog-trader into a hilarious character named Sparrow, who is prominent in *The Man with the Golden Arm*, and prominent again in the Otto Preminger movie of the book as a pal of the eponymous dealer played by Sinatra.

"How does God find time," Nelson mused, "to go from an Ashland Avenue dog store to the Pacific Garden Mission on South State? I'll bet he rides a stolen Schwinn bike."

For a while "Poole's Healing Service" on Lake Street did a brisk business using voodoo artifacts and fake little bottles of curatives like "Compelling Oil," which, when sprinkled on a man's food, "makes it impossible for him to resist you." A best seller at 50 cents. Algren gave his bottle to de Beauvoir. "It worked—for a while," he reported. Like the sisterly first aid above.

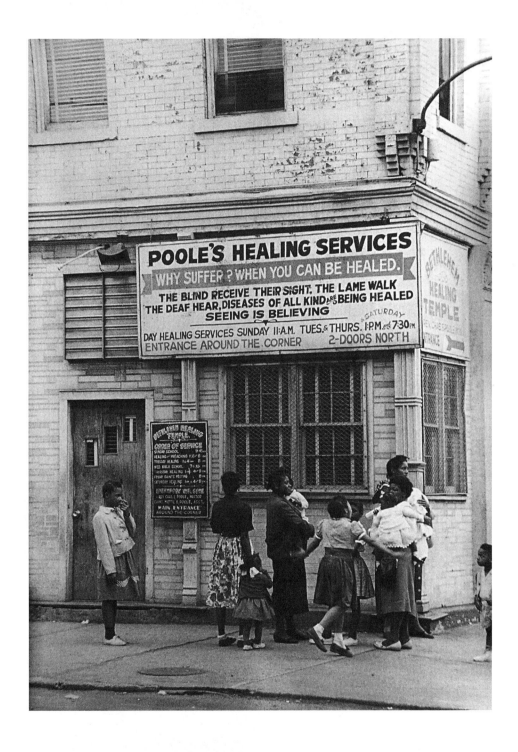

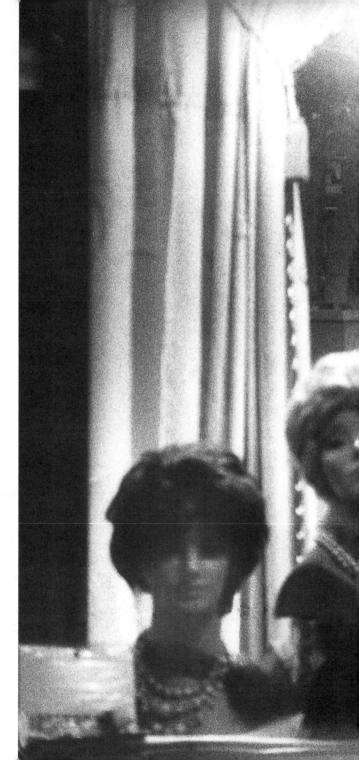

At lectures I'm often asked which is my favorite picture of the 25,000 or so I've published. I unhesitatingly point to this one. Nelson and I were wandering south on Ashland Avenue near Division one night when he spotted this modest beauty shop that apparently catered to working women by staying open until midnight. I lifted my Leica—to compose the cheery mannequins—when I noticed the little old lady under the big dryer. So there I had it. We all want to look like the pretty mannequins—but life intrudes.

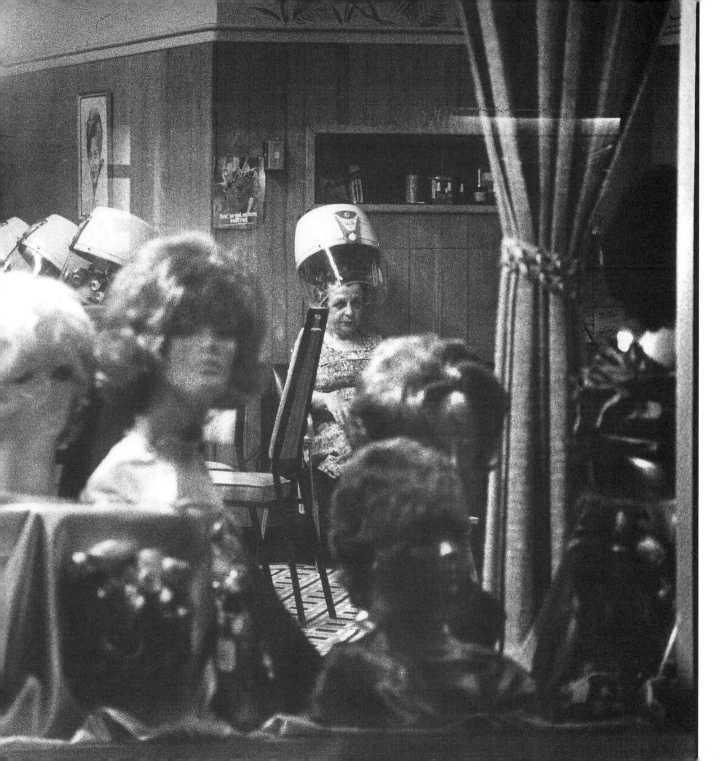

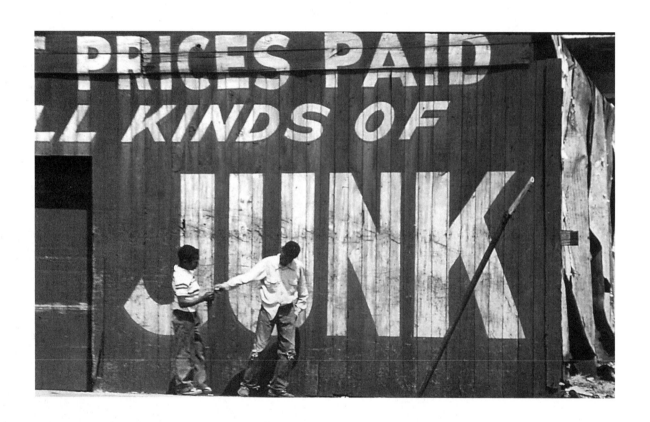

Like other towns, Chicago is a city of people paired in their private worlds.

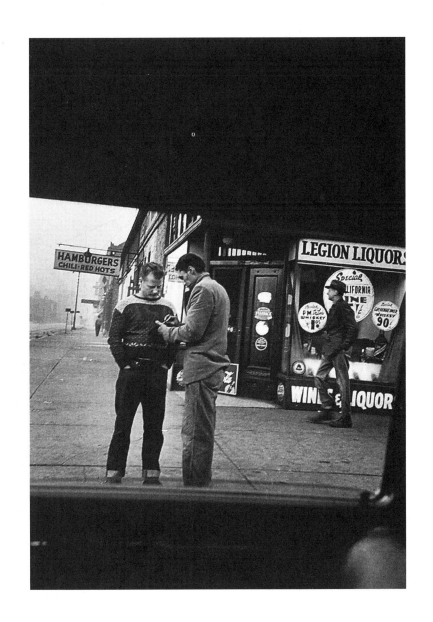

Life magazine was on the fence about devoting 8 1/2 pages to a writer who had just won the first National Book Award. So they sent me back to Chicago to get releases from drunks, bums, and in this case a woman who offered to party with Nelson the whole afternoon for three bucks—to cover the drinks. An editor of *Life* muttered he thought I had hired a model for this picture, like the ones who would be hired by the great Doisneau in Paris to show young love in Paris springtime.

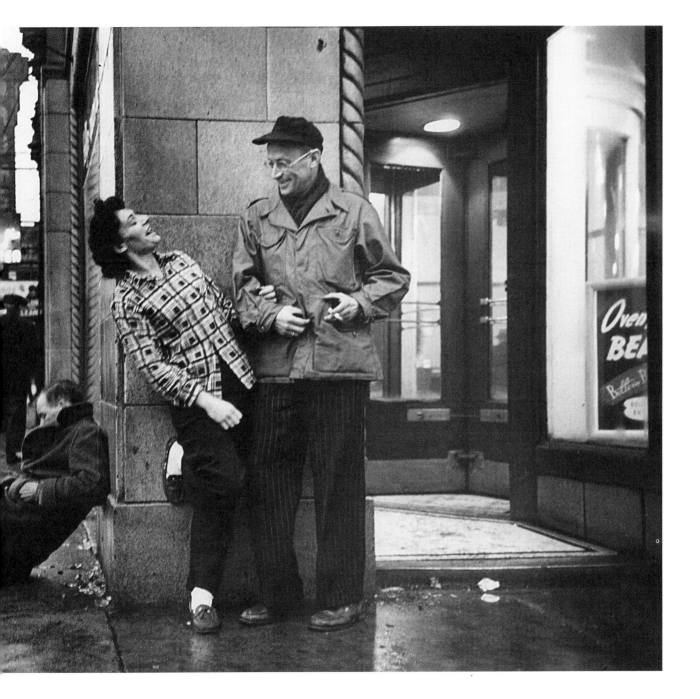

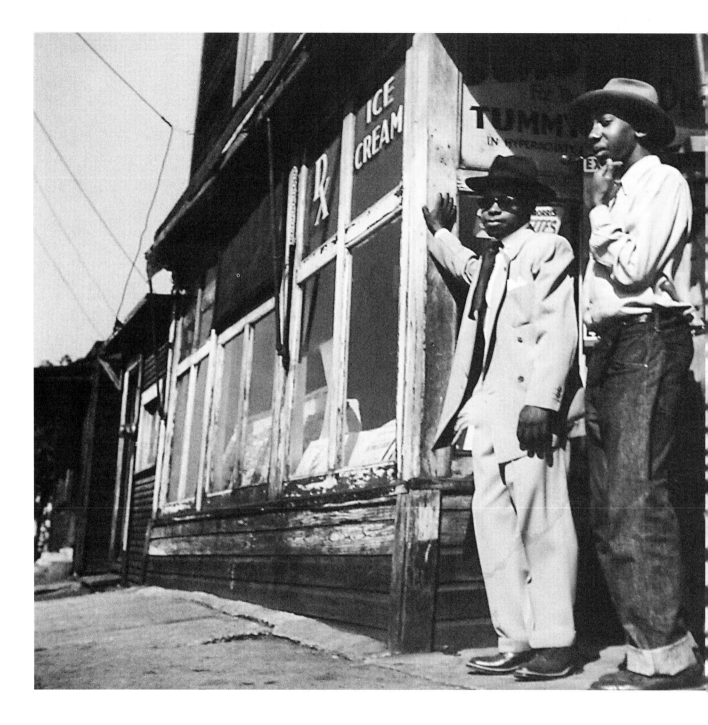

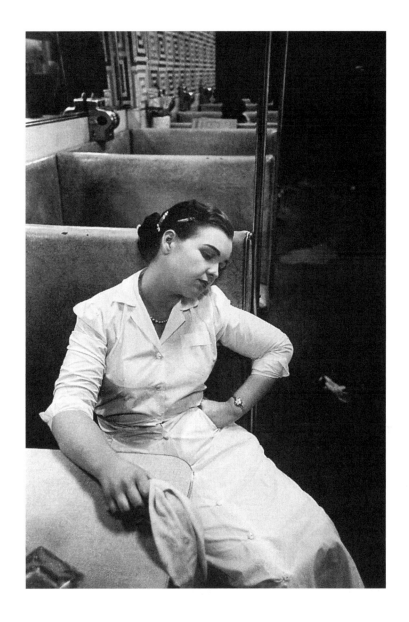

In a south Illinois town called Brooklyn, I followed some Chicagoans who had become locals, living off their wits.

Algren liked closing time at neighborhood restaurants and never tired of listening to the adventure tales of hard working waitresses.

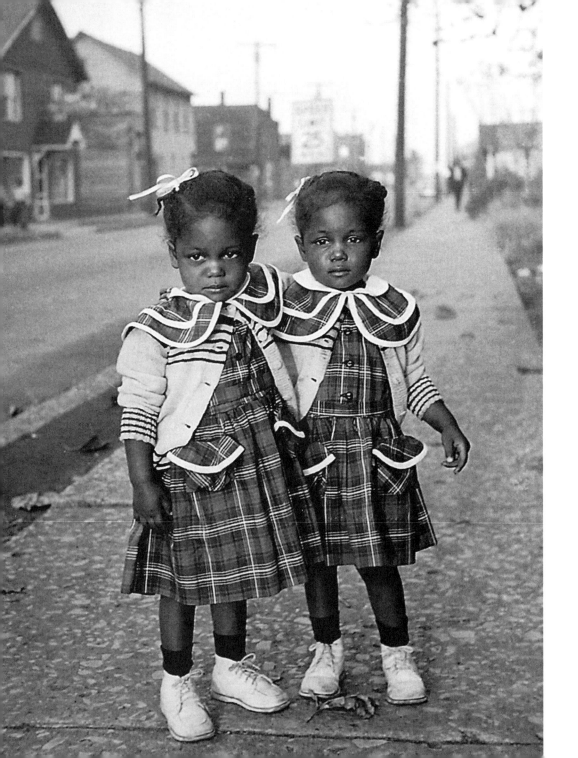

Algren and his good friend Richard Wright (who wrote *Native Son*) loved wandering through Illinois, and then Paris, for the same reasons: they found a dignity and lack of self-consciousness in poverty that they liked better than what they found on the Gold Coast or Les Champs Elysees.

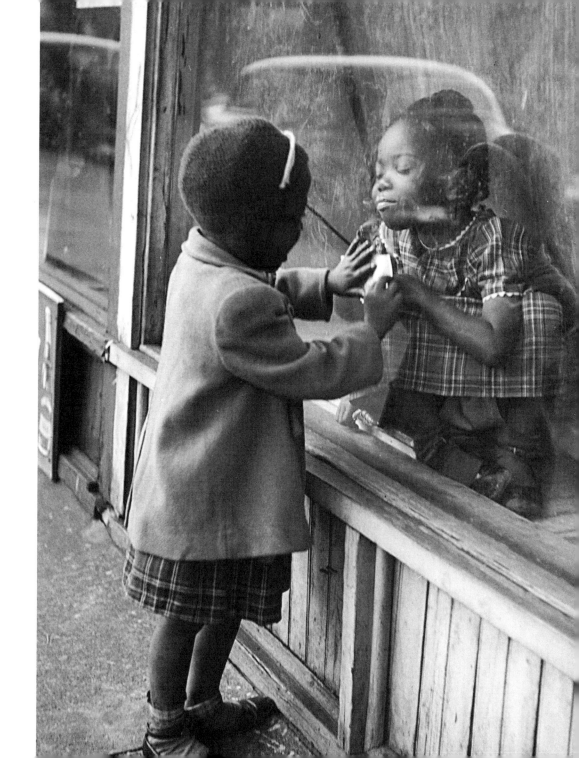

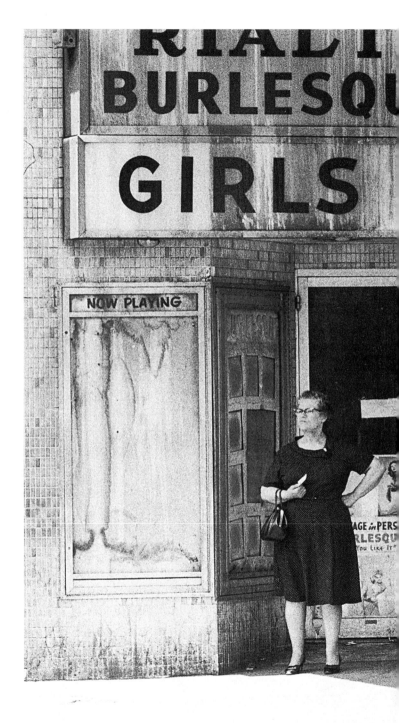

The Rialto Burlesque, soon to be wrecked for an office complex, had once featured Jean Harlow's niece, who costumed herself like "The Blonde Bombshell"—platinum, really—that her aunt became in Hollywood.

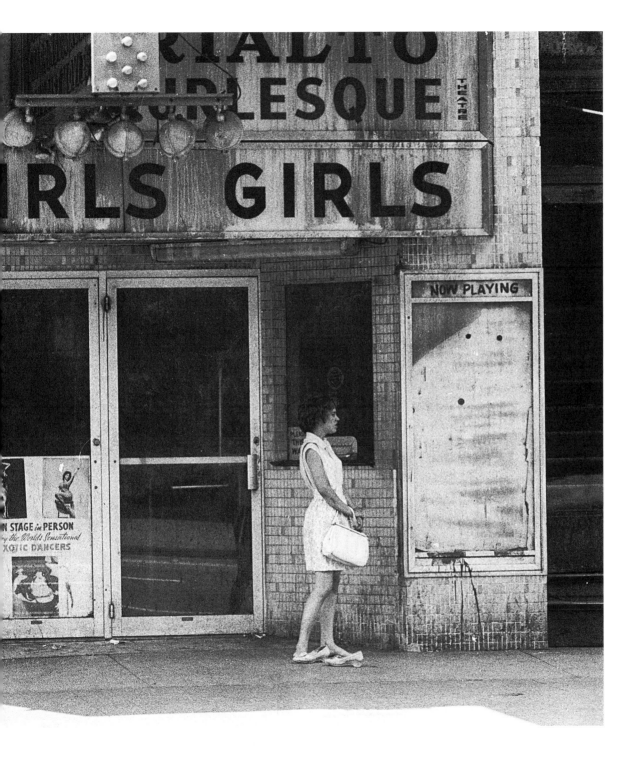

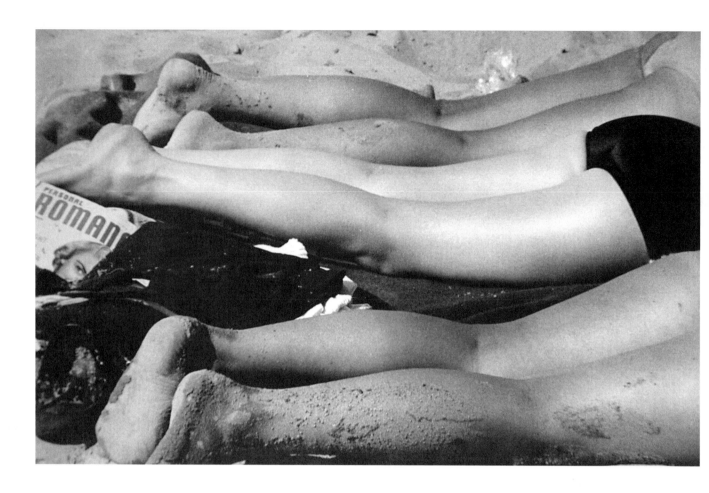

Romance was the name of the beach-girls' magazine, and *Titter* was the favorite reading matter of strip-tease artist Jean Gemay. I was doing a story on her as a real-live strip-tease artist—she painted pictures of herself performing—for *Life* magazine.

"Can I ask you a question?" Jean said as we wound up the shoot and I gave her number to Nelson, "You ain't queer, Art, are you?" When I shook my head she said, "Then you're the first photographer who ever took my picture and didn't try to fuck me. How come?" All I could think of to say was, "I think you're very pretty, but I'm saving myself for an orgy tonight." She understood perfectly and next time I saw her wanted to know how the orgy was and if she could get an invite to the next one. "Your friend Nelson is sweet," she said. "But I think he had some other broad on his mind."

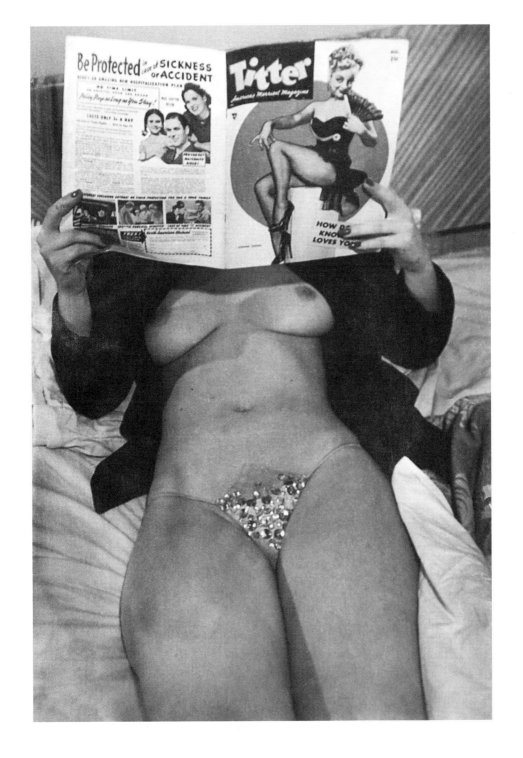

The eye of this photo-journalist finds it hard to resist the visual pun. One influential Chicago art critic has disparaged this picture as a one-liner. When I was younger this bothered me, but when I passed 80 I realized that my eye has been, among other things, a playful hunter, a restless concatenator. For better or worse I couldn't possibly change its humor any more than I could change its humour. Any more than Mel Brooks can stop seeing his world his way. Nelson said, "Simone loves this picture as a portrait of the dominated woman, but wants to know why you blurred her. To make her universelle? Something like that." The authoress of *The Ethics of Ambiguity* addressing one of my pictures? Wow! Actually the blur came when I had to use a slow shutter speed because the film was slow, the light was poor, and I had miles to go before I rejoined my exposure meter.

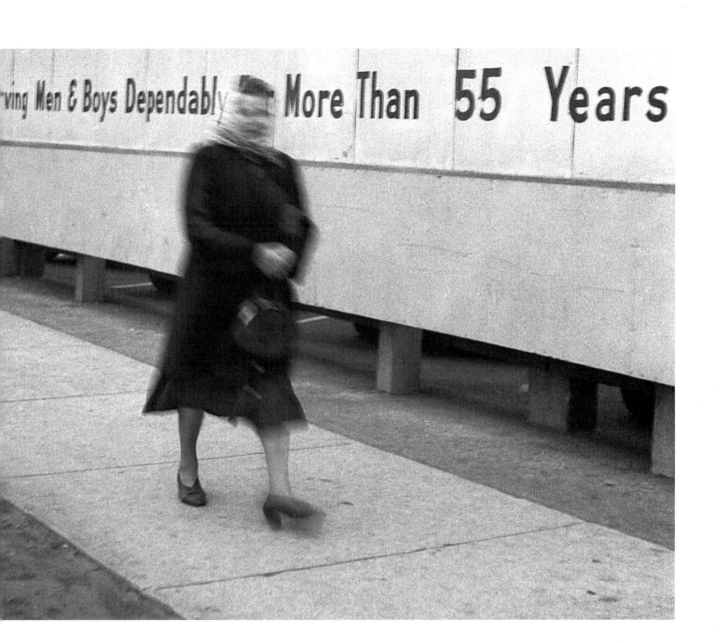

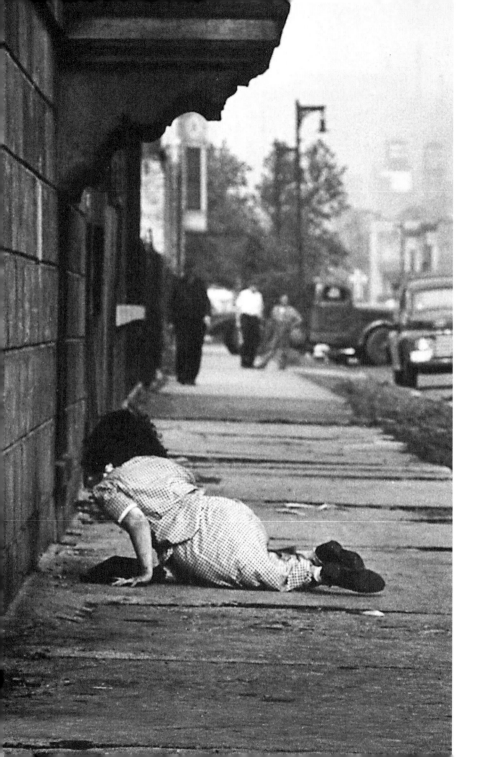

Not far from this fallen woman on Madison Street, a veteran couple of beggars average about ten bucks a day. The great photographer Walker Evans photographed this same couple a few years before me. His picture, less the "Need Cash" conceit of my Rolleiflex, hangs in several museums.

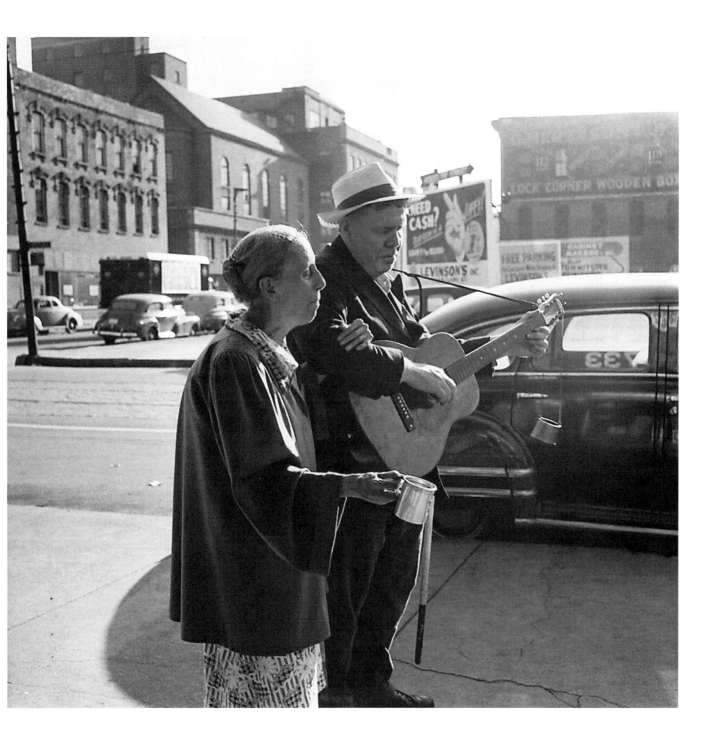

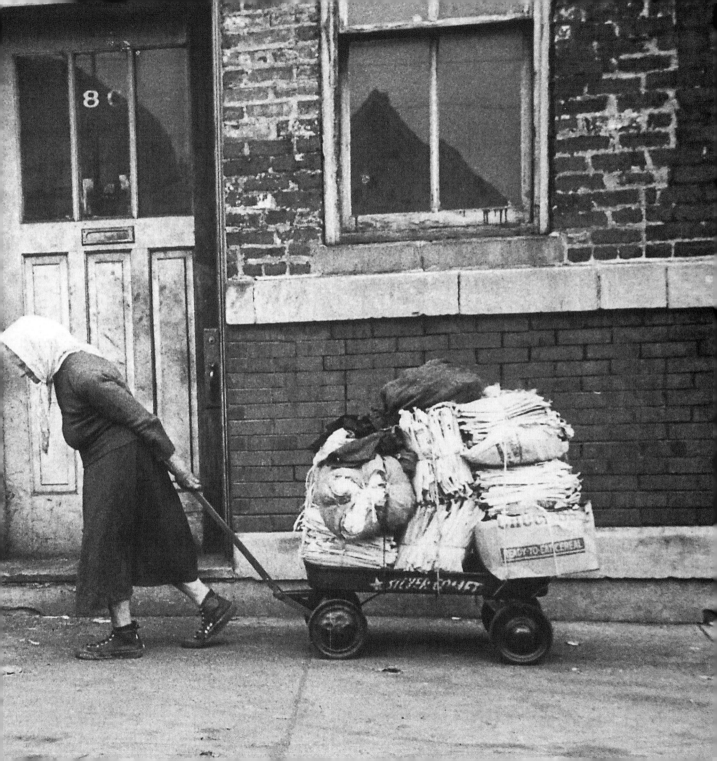

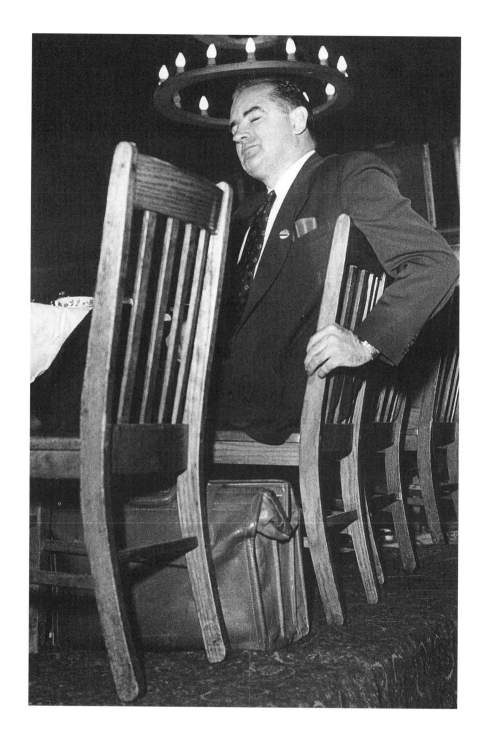

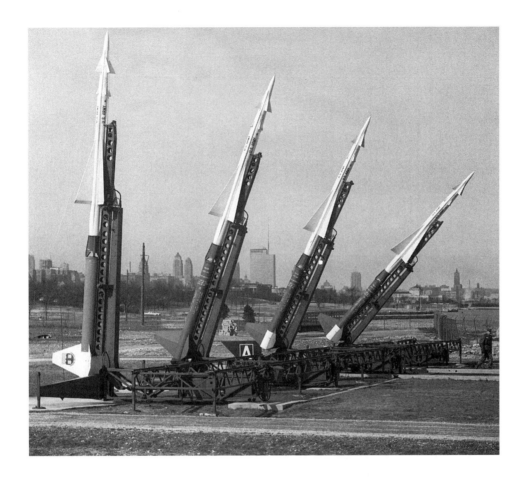

From 1950–1954, Wisconsin's maverick Senator Joe McCarthy held our country, the Soviet Union, and two American presidents—Truman and Ike—in his wicked thrall. He also kept intellectuals with left-leaning pasts, like Nelson, from getting passports. His spurious battle cry was, "The 'Commies' have taken over our government." Thus I pinned the ironic halo on him. Thanks to public TV hearings in which his nihilism and prejudices revealed themselves as bullying and phony, he was officially censured—condemned—by the Senate. He died of alcoholism three years later.

During McCarthy's "Commie" scare, Chicago Mayor Richard Daley, ever protective of Chicago's Loop, sought and won hair-trigger missiles from Washington as protection against Soviet h-bombs incoming across Lake Michigan.

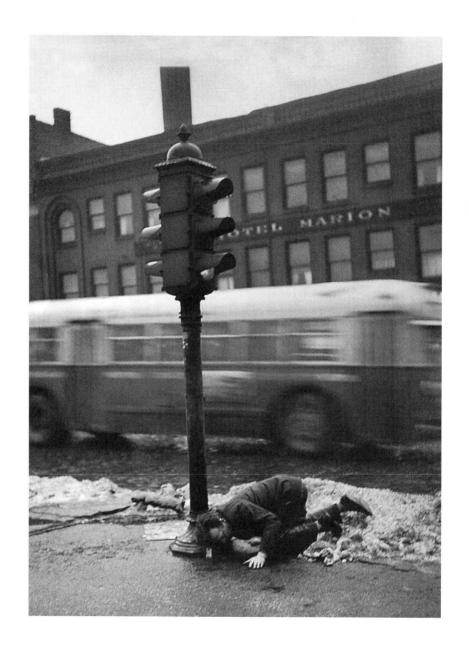

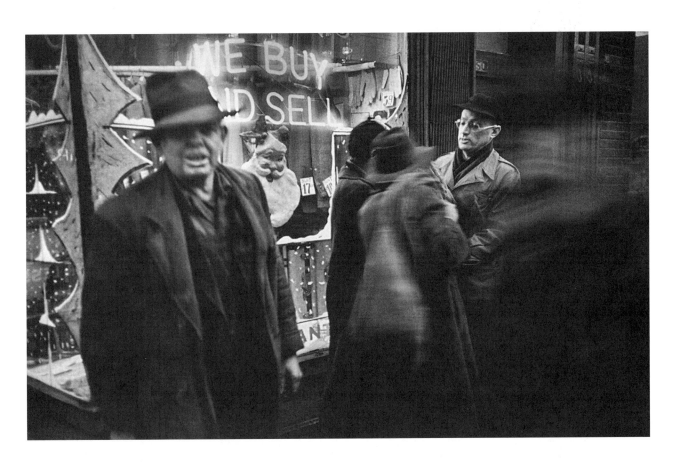

"The guy looks like he just slid safe at home," Nelson said about the sidewalk man.

"Gimme your camera," yelled the bum. "I could get a bottle of Gilbey's for it."

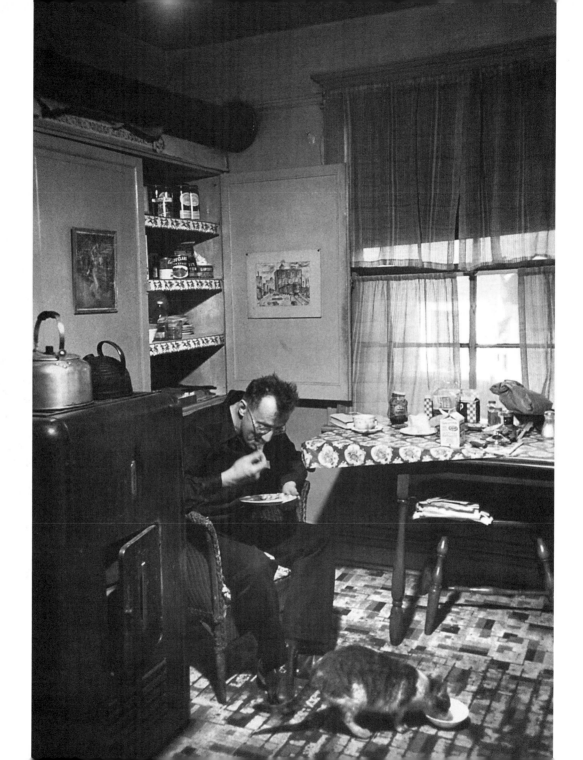

Until Simone de Beauvoir came to share this $10 a month apartment on Wabansia, Nelson's favorite dining companion was his cat, Doubleday.

At an all-night restaurant on Clark Street near Division, Nelson almost always picked up a good story from the next occupant of an empty chair at his table. He often ate here with the crooked original of "Sam the Bookie" one of his hilarious racetrack stories.

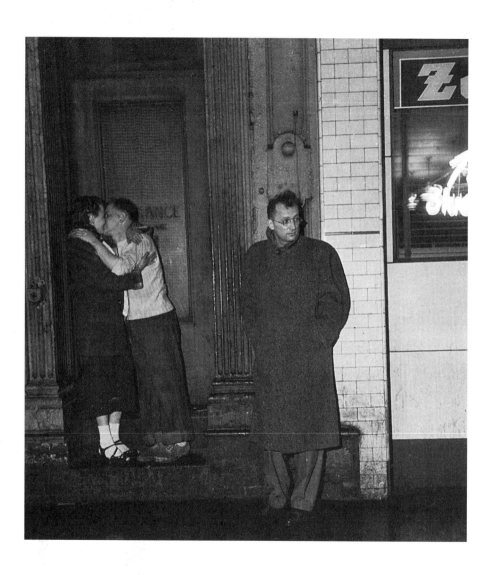

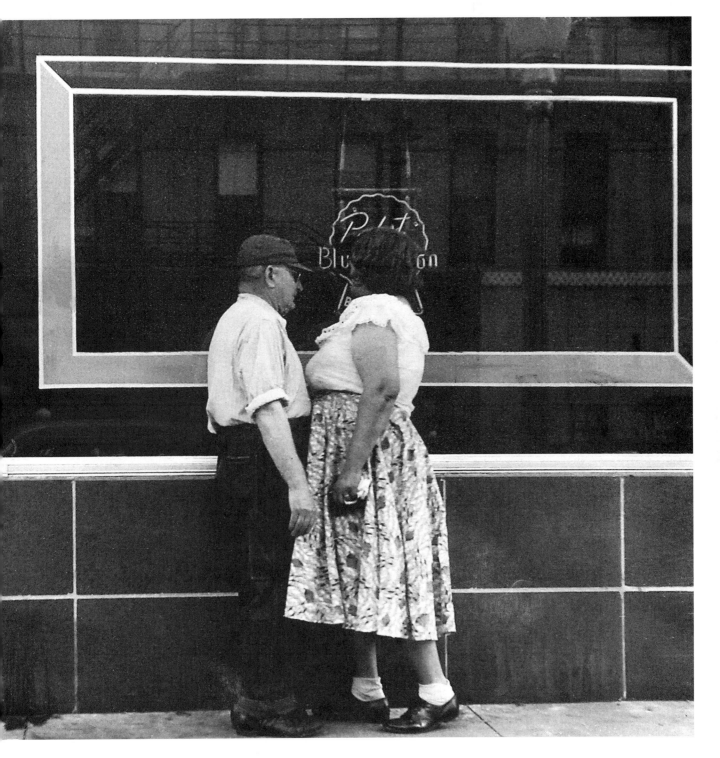

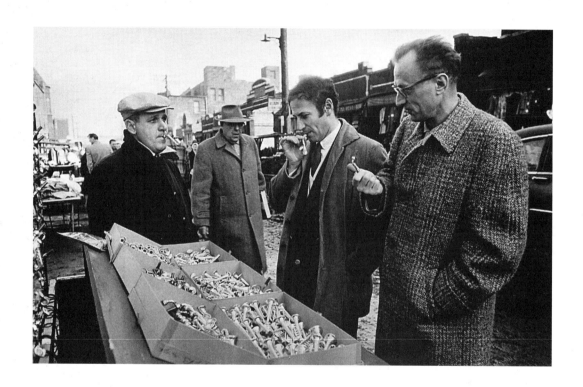

On Chicago's famed "bourse" or street market, Nelson and our friend Marcel Marceau, the great pantomimist, check out a toystand. Marceau kept an ongoing visual notebook of characters we showed him in Chicago, then used some of them in his tableaux all over the world. At one North Side Irish bar we frequented, that kept a trunkful of Civil War artifacts, Nelson and Marcel seriously reenacted a classic duel. "If you have to hit anything, Nelson," Marcel whispered, "hit my mouth—I do not use it in my work." "Don't hit my dick," the tipsy Nelson rejoined. "You would have one unhappy philosopher cocksuckaire." "Ah oui—Simone," said the admiring Marceau. "You're a lucky man."

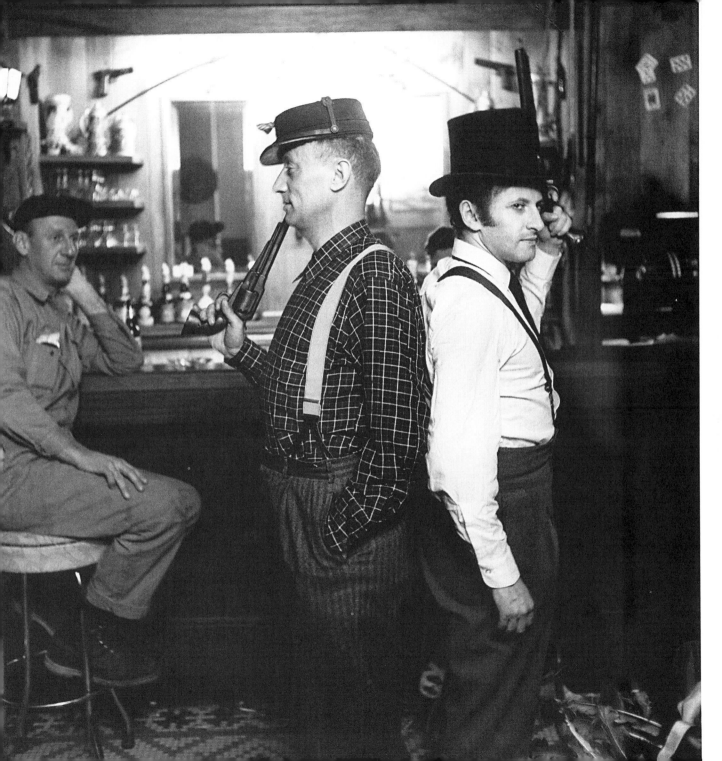

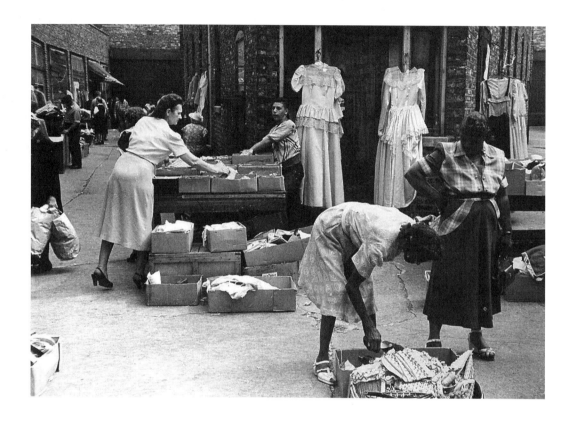

The owner of this Maxwell Street sales pitch keeps a wary eye on all potential customers for shoplifters. His suspicion covered this photographer at the moment. This stand is not far, Nelson recalled, from Big Jack's—a shoe emporium at which "Frenchy" was able to get wide shoes and some goofy shower shoes. She loved that the prices on Maxwell were cheaper than on her home Bourse. She thought maybe it was cheaper because in Paris they knew she had money and here she looked like some frugal housewife from Milwaukee Avenue by Division. The father and son bric a brac proprietors were muttering to each other in Yiddish. When I said, "Nein, mir zenen nicht polizei," they were relieved. "Shouldn't it be worth something, taking our picture?" said the father. "Someday it will," said Algren. "This is a Rembrandt of the lens." "Who is Rembrandt not of the lens?" he asked. "And who cares?"

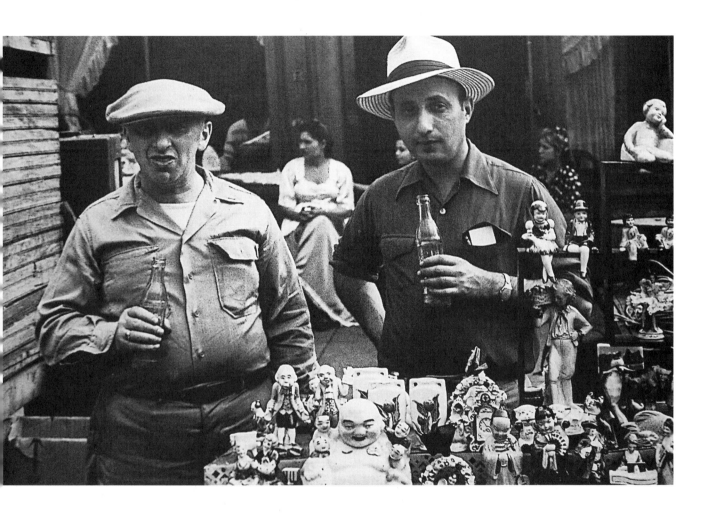

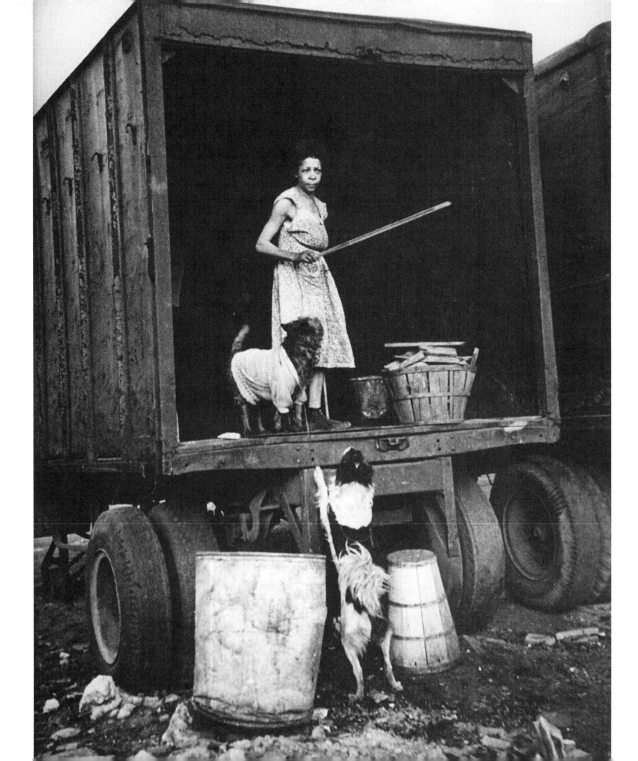

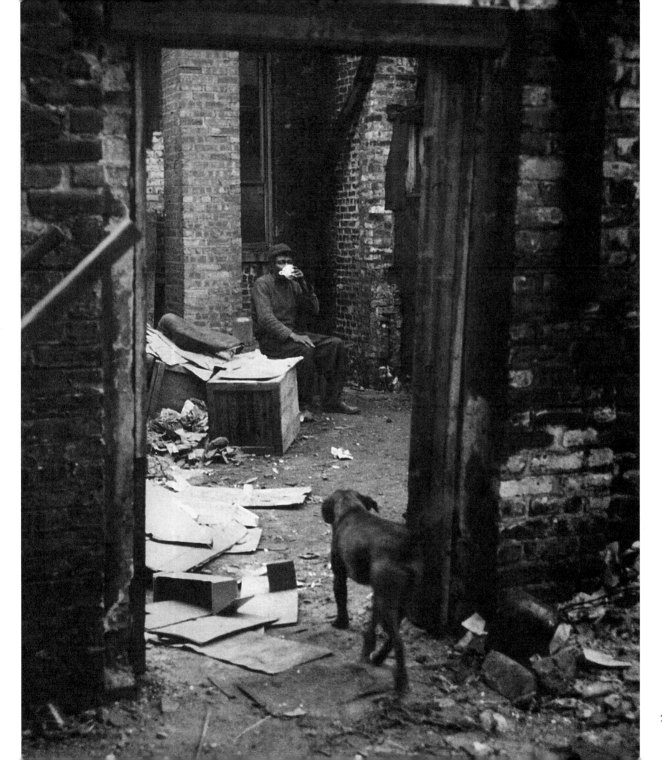

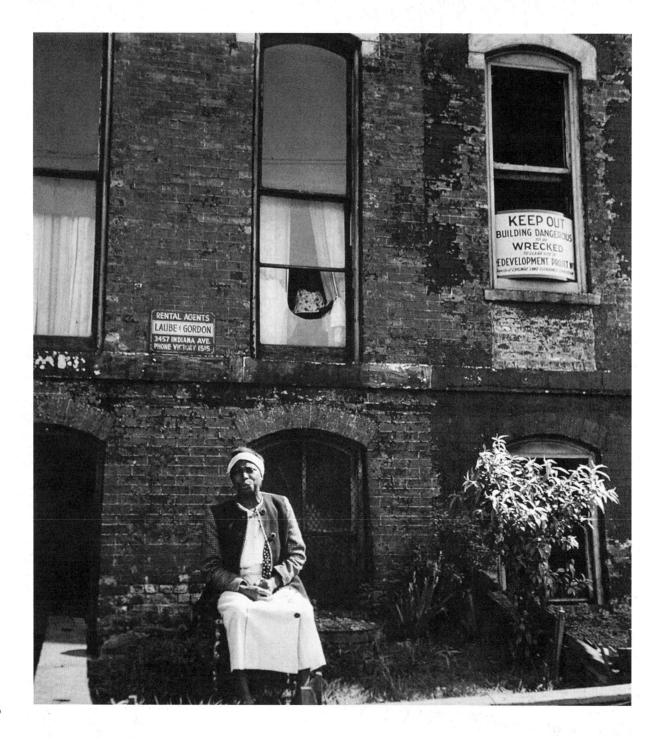

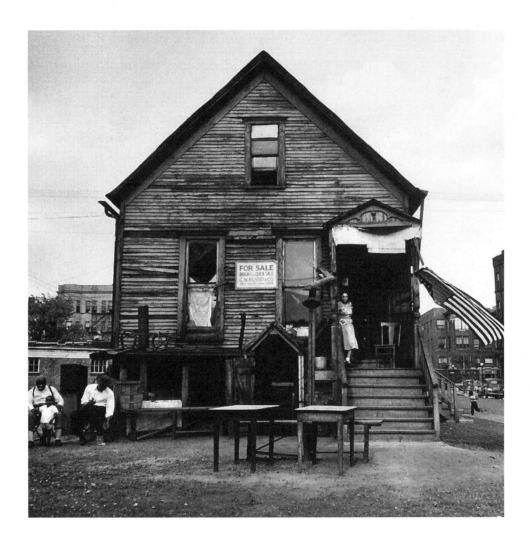

The self-cancelling "Keep out" and "House for rent" signs say it all as this grandma warms herself in the autumn sun and her granddaughter peeks out the condemned window.

The proud flag is for a son lost in the Korean War in the early Fifties

The neatly dressed children emerging from their condemned building into Sunday morning sunlight are waiting to go to church. "We got a lot to thank God for," their father told me, thanking me for my two dollar contribution.

It would be easy to ascribe sociological symbolism to the four boys intently rolling two small racing cars inside the tub. Strictly speaking, the picture could better be an indictment of Chicago garbage collection on the near South Side under the Lake Street El, back in 1949.

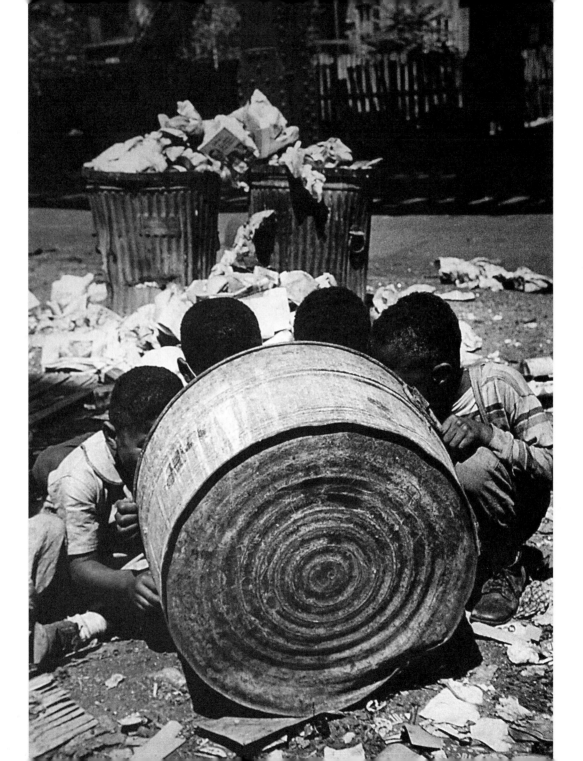

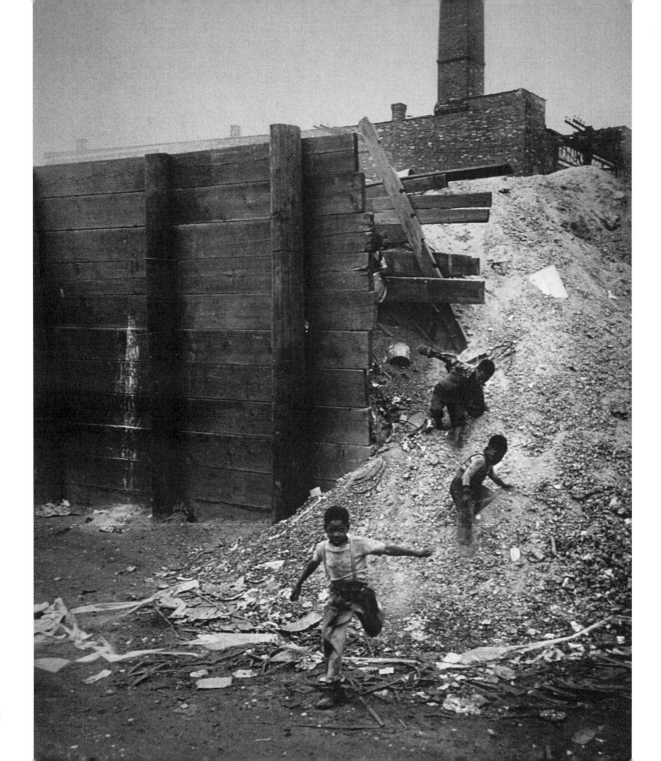

Chicago was a city of myriad playgrounds for resourceful children before the neighborhood playground came into vogue. These children reminded me of my old haunts on the empty lots of the east Bronx, a congeries of half-cleared ditches that couldn't support structures because of the Depression in my generation.

Nelson was not surprised to be "gunned down" by kids on Milwaukee Avenue, but Senator Estes Keauver, Adlai Stevenson's VP running mate in 1956, made light of his hold-up. He was after all, the head of the U.S. Senate Crime Commission at the time.

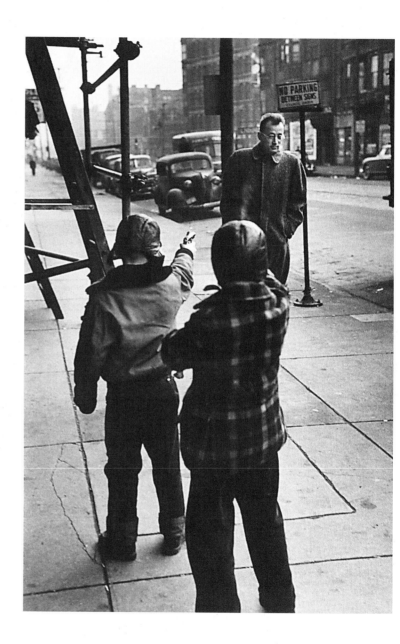

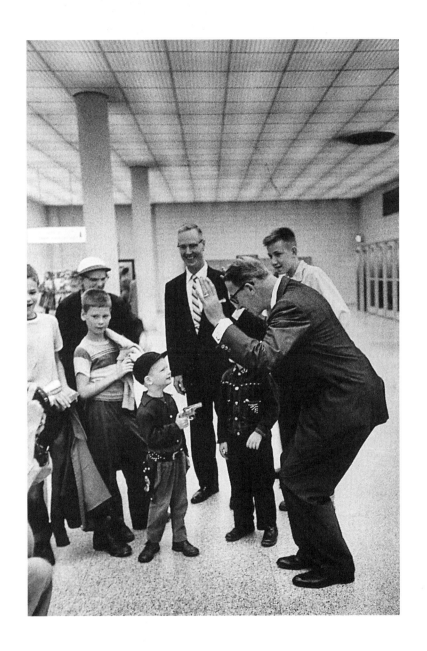

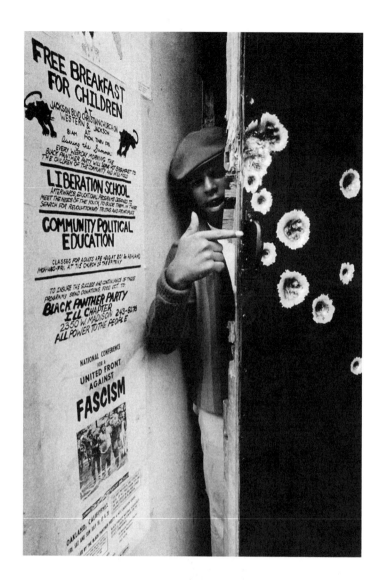

A wary Blackstone Ranger shows off the bullet holes made by police when they killed Fred Hampton. Despite police testimony that they had been greeted by a barrage of shots, only two bullet holes were found to have come from the apartment.

At a newly integrated apartment complex on the far South Side, the police, warming themselves around what's called a "salamander," guard the first black tenants from their outraged neighbors.

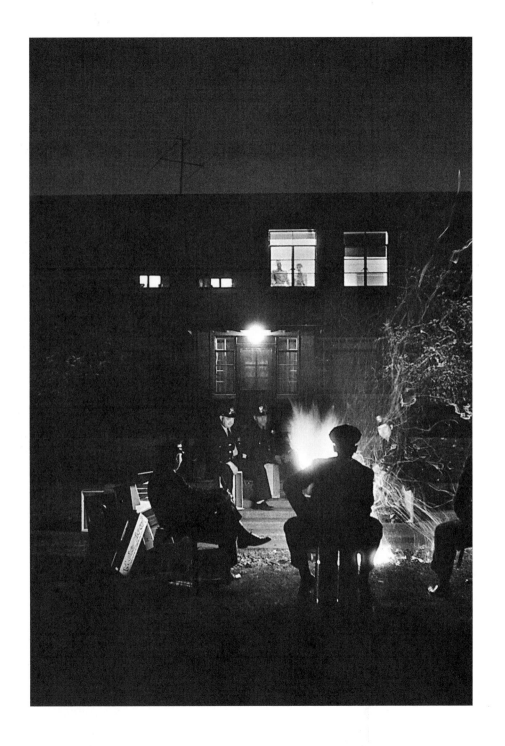

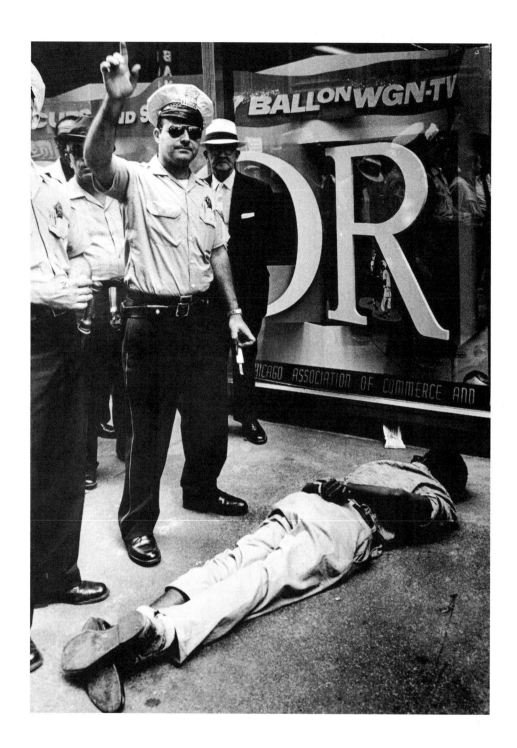

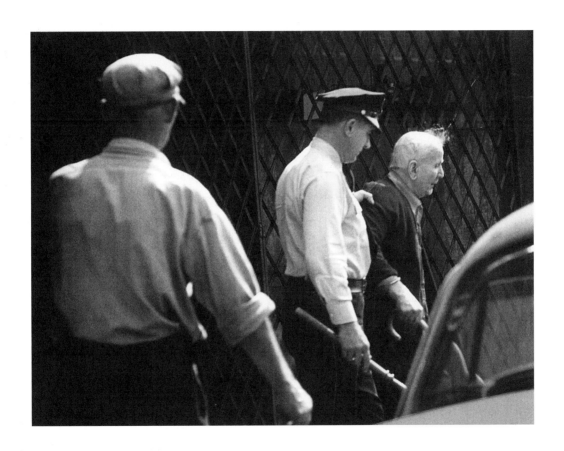

Ever diligent against miscreants, regardless of age or color, Chicago's finest did fairly well until 1968, when a national report accused them of "rioting" against marauding Hippies at the Democratic National Convention. (see pp. 42–43)

When Nelson and I wandered Chicago courtrooms it would be years before metal detectors ruled out cameras. The big "security" change occurred after JFK's assassination in 1963. In the forties through the early sixties, my reputation and press card as a Time Inc. photographer usually cleared the way, and when that wasn't enough, a discreet five dollar bill always worked. FYI—the mantra of Chicago police taking money in those days was, "Are you sure you wanna do this?" I was always sure and was never turned down.

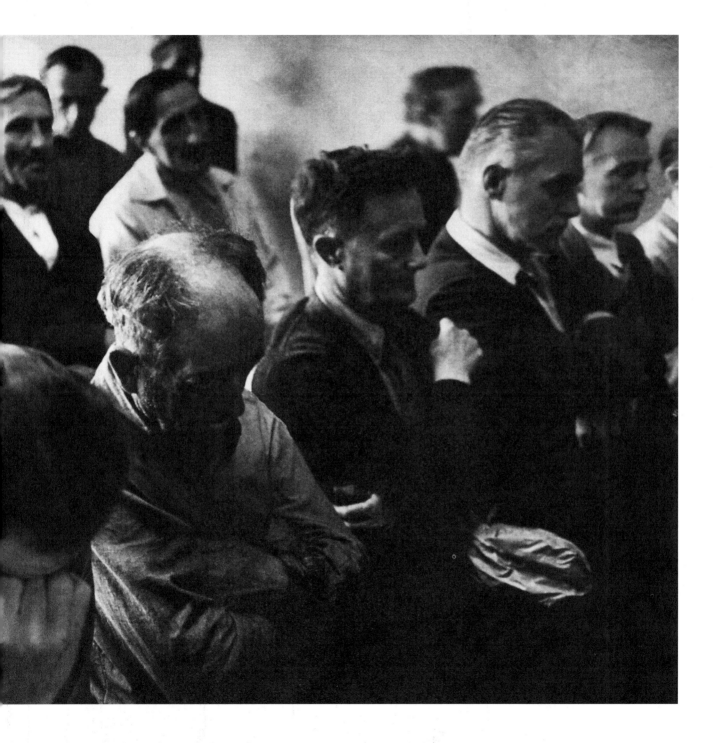

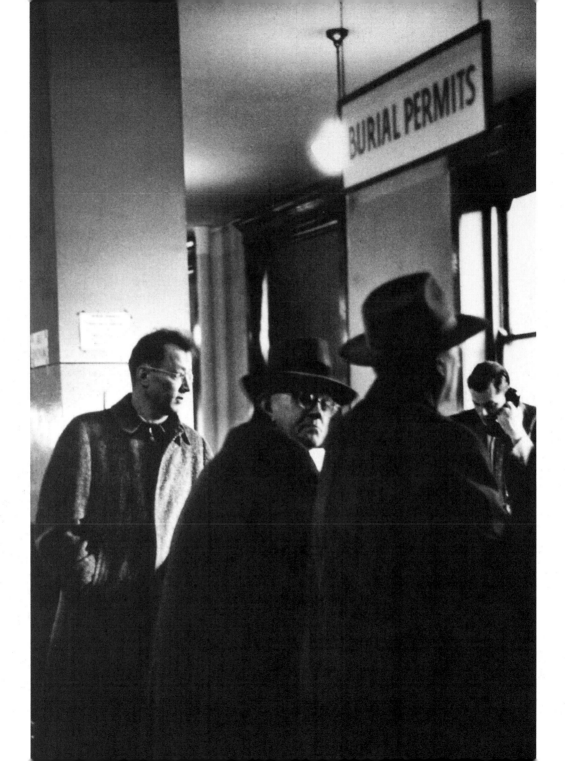

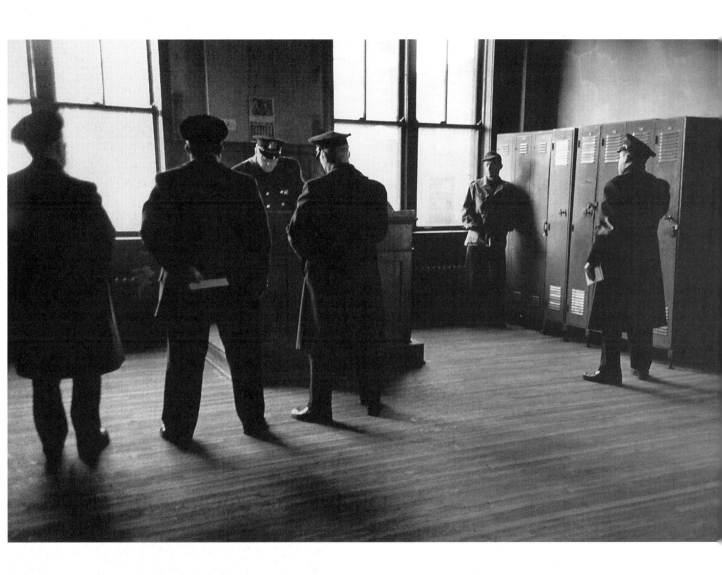

Having always been suspicious of the corrupt police of his generation and having worked for the impossibly ineffficient City Health Department, Nelson liked to keep an eye on whatever institutions he could explore.

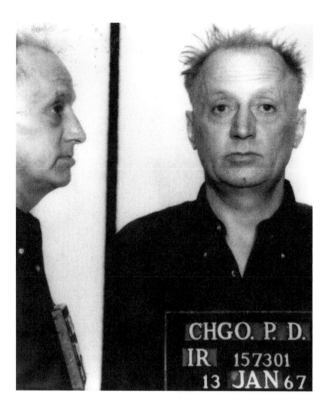

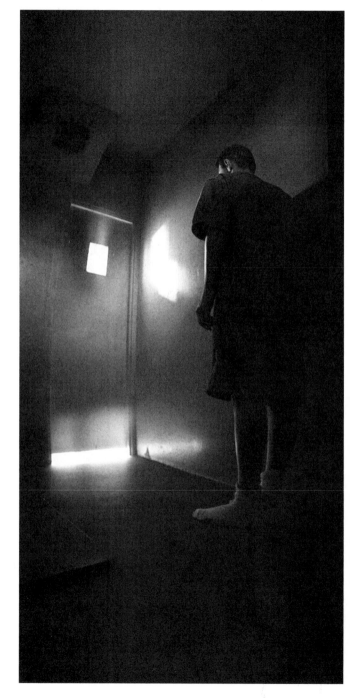

Nelson used to tell the story of his 1967 arrest on a minor spurious matter as a joke on his friend and lawyer Ted-L. "Teddy got them to knock down the charge of keeping one of my books out three weeks overdue to a misdemeanor—and I was on the street in five months. With a four hundred dollar fine. What a lawyer!"

We visited the juvenile detention center at St. Charles with Marceau—my *Time* magazine press pass let us tour the old jail at police headquarters at 11th and State. Actually, as a youth, Nelson spent three months in a Texas jail for appropriating a typewriter he thought was abandoned. Thus he was always sympathetic to jailbirds.

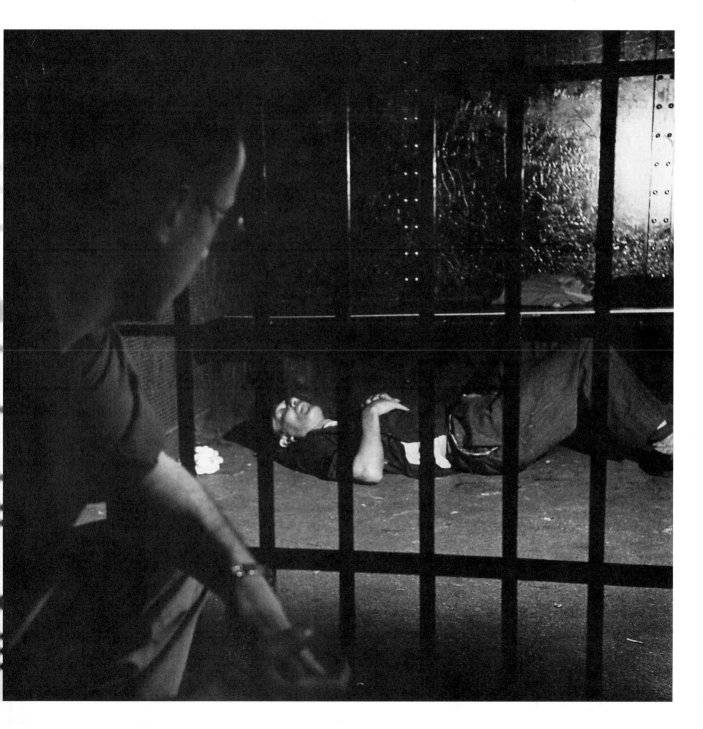

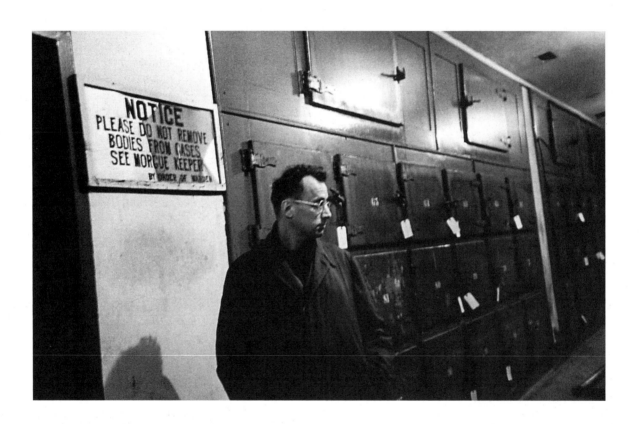

Though he thought the idea of an afterlife was preposterous—a God would have so much cruelty to be accountable for—Nelson was interested in our treatment of the poor and homeless who died in Chicago. With a hidden camera we sneaked into the morgue and its unofficial medical branch, the Washem School of Undertaking, which rented space at the municipal hospital and sold unclaimed bodies to medical schools.

The show-up at police headquarters was one of Nelson's favorite stops when showing visitors our town. His rickety Schwinn bike had been stolen by a thief he saw pedal south down his alley, and so had a police ticket entitling him and a guest to view the weekly parade of suspects caught red handed. The official hope, often realized, was for victims to identify their assailants. Algren used the colloquies between the tough police judges and the prisoners in "Arm" and in several short stories. "Wasn't you here for molesting a little girl three months ago?" "No your honor, it was a little boy." Nelson took de Beauvoir here and also Norman Mailer, who, thinking to flatter him, got it backward, saying, "They sound just like your characters."

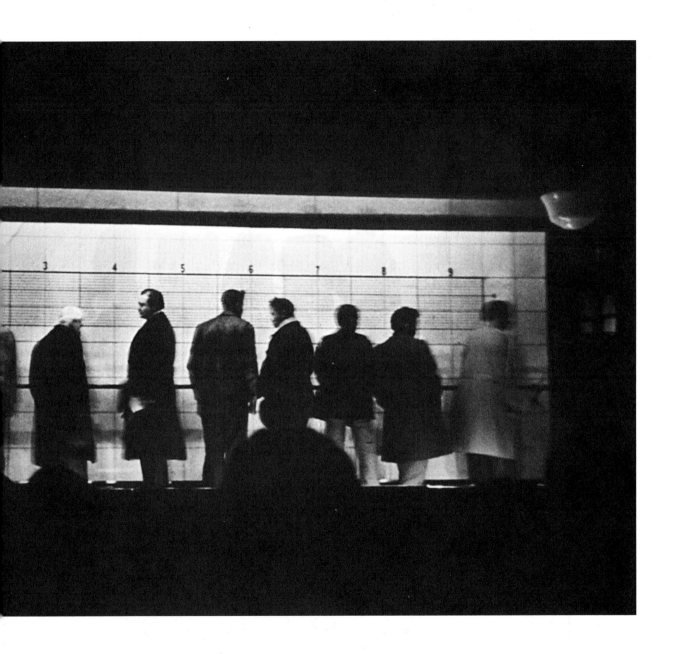

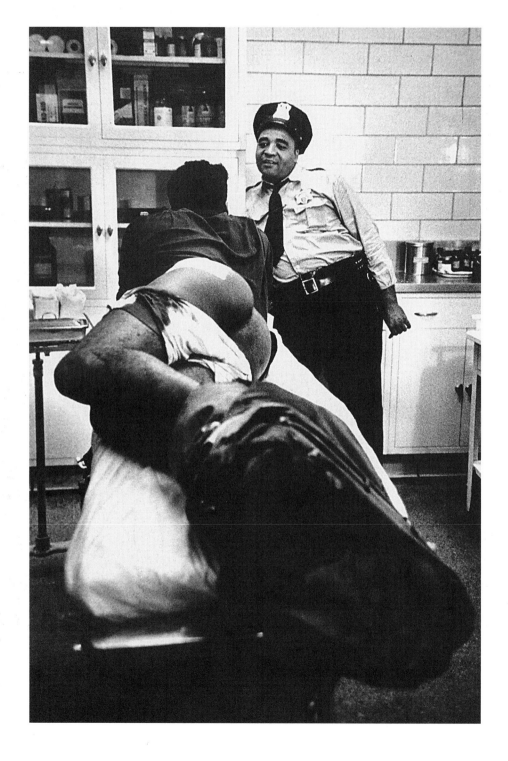

"I was outta this place safe I thunk then I gets shot in the ass . . ."

This strong-arm robber, masquerading as a whore, testified: "Judge, female impersonation isn't just a silly hobby with me. It's my bread and butter." Nelson wrote the quote on the back of the picture.

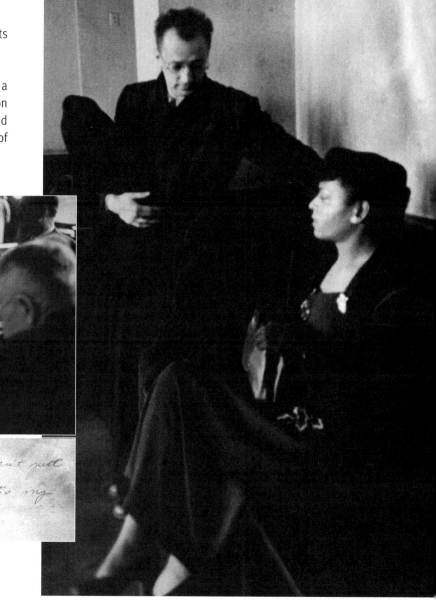

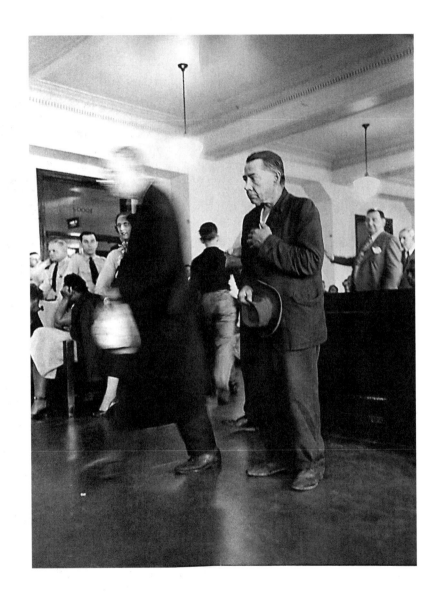

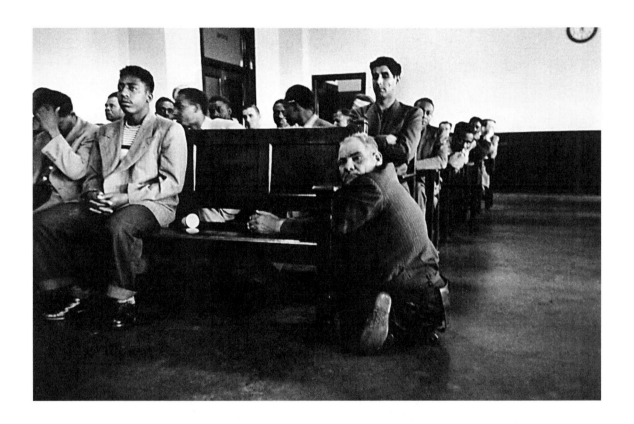

In those halcyon days before metal detectors, the only reason to hide my Leica (in my cap, under my jacket, peeping through a pocket hole) was to achieve the kind of bland invisibility necessary to get some of the pictures on these pages. Sandy Smith, Chicago's greatest crime writer of that era, with whom I had done many of Life's Mafia stories, once wrote in Life that "Art Shay has the guts of a second story man." It was the greatest praise I ever received until Garry Wills, the great reporter with whom I covered the murder of Dr. Martin Luther King, called me "courageous."

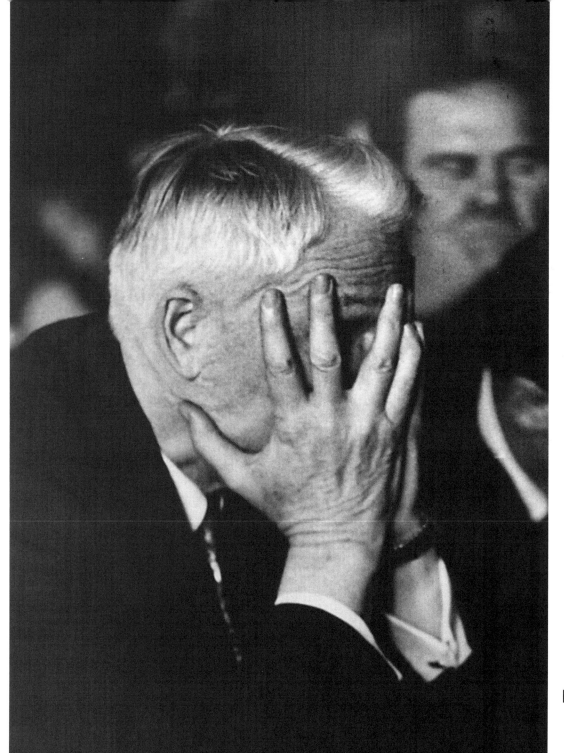

PROSECUTOR.

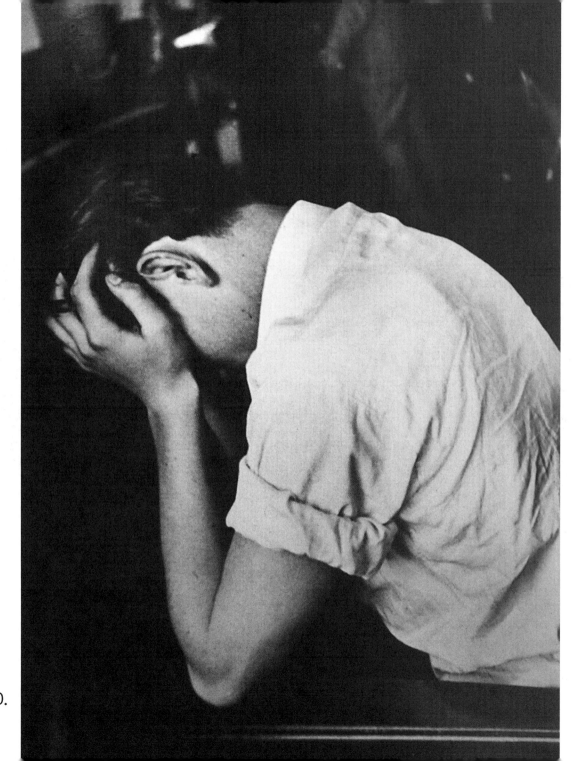

PROSECUTED.

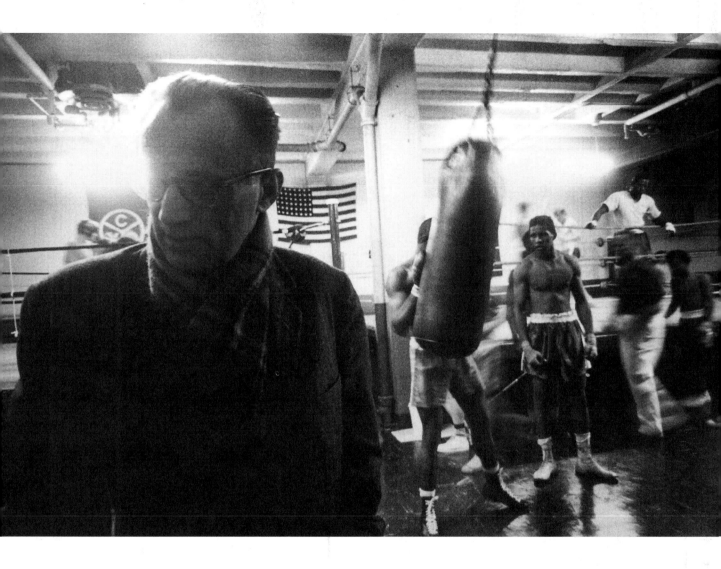

As a frustrated club fighter Nelson loved to frequent boxing clubs like this CYO training ring on Wabash Avenue run by a friend, maven and former champion Tony Zale. He loved to stand in the shadows and watch the hard-hitters train, as in this cover shot for the latest (Seven Stories Press) edition of *The Devil's Stocking* about the rise and fall of Hurricane Carter. On his own, most days, Nelson liked to punch the heavy bag at the Division Street Y near his apartment on Wabansia. "Madame," he once boasted, talking of de Beauvoir, "said my stomach muscles remind her of Edith Piaf's guy, [French boxer] Marcel Cerdan." Then he added proudly, "I'd have lasted maybe two rounds with Cerdan. Frenchy said he fucked Edith Piaf's brains out every day. That takes good abs." (Cerdan later beat Algren's friend Zale for the world middleweight championship.)

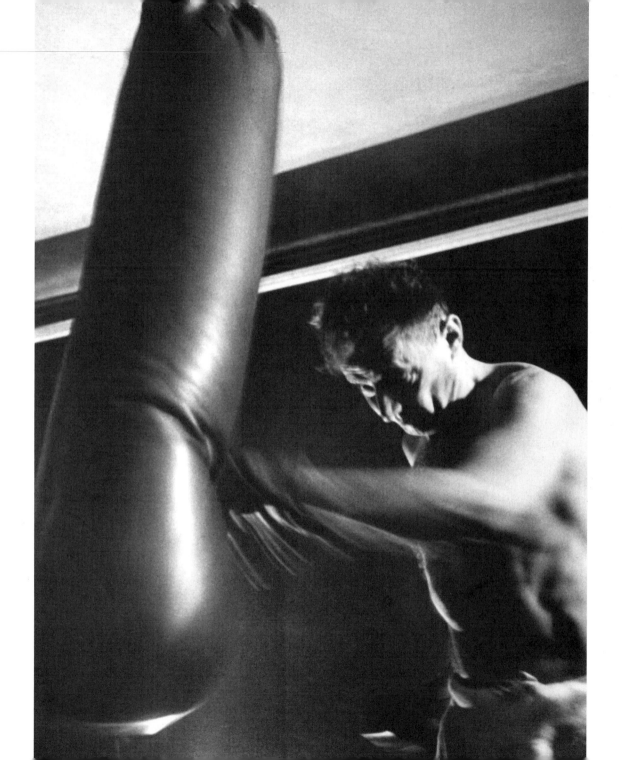

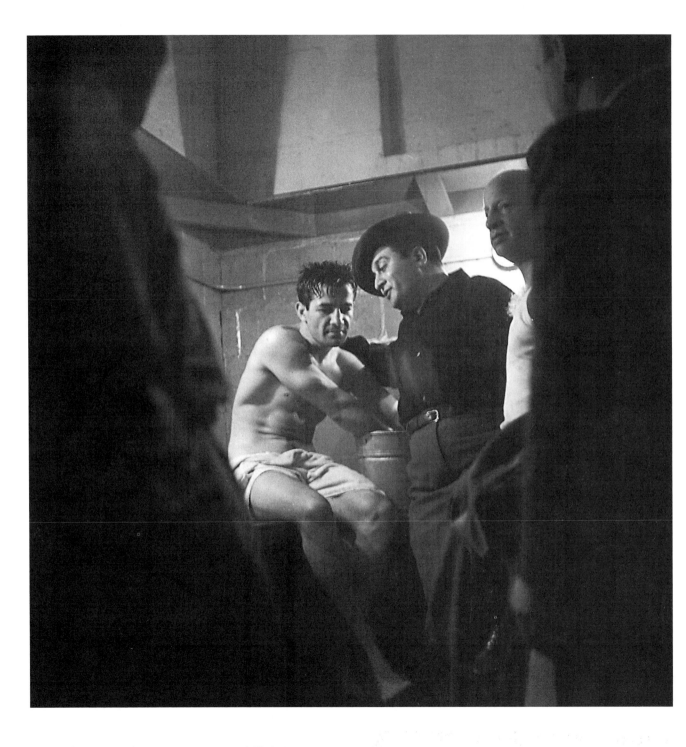

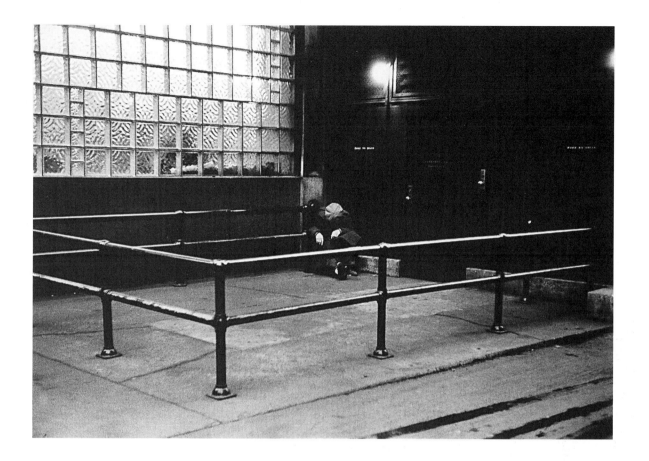

Nelson loved the photographic inference of a subject seeming to inhabit two worlds at the same time. Behind Chicago's old Main Library I found this all-night bum, the kind, Nelson has written, "wakes up lookin at the cats . . . his face as gray as the hindquarters of adversity." To me he seemed like the stumblebum played by Marlon Brando in "Waterfront," the one who said, "I coulda been a contenda . . ." In my eye—given to visual pun—the library's shipping enclosure looked like a boxing ring.

Fighter Rocky Graziano, left, ices his hands after icing Sonny Horne.

Nelson loved the industry shown by the kids adding up their shoe shine earnings outside a bank. He also delighted in some of my visual puns.

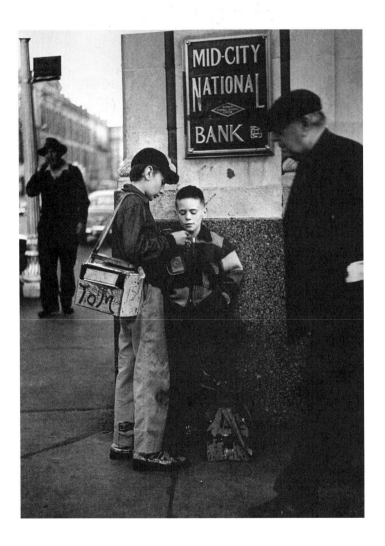

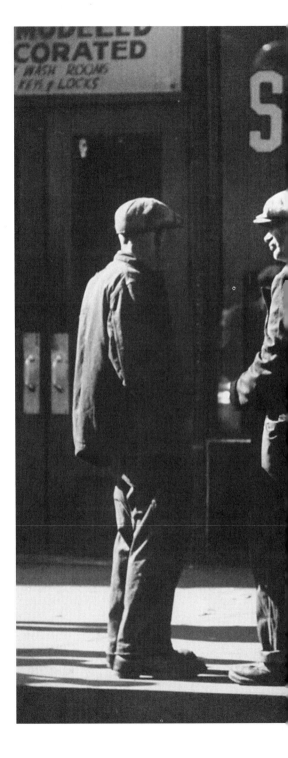

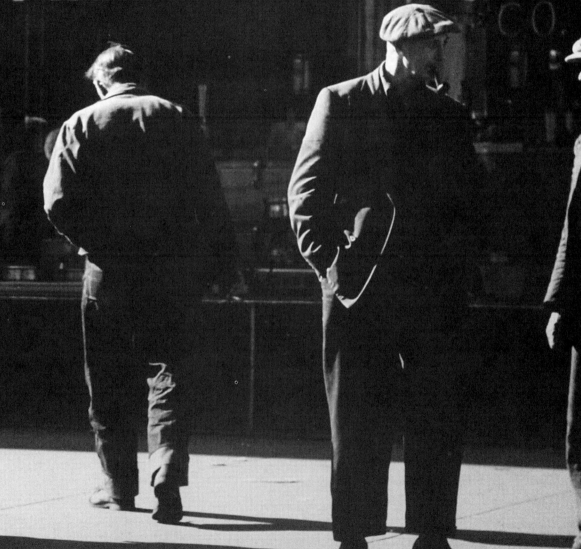

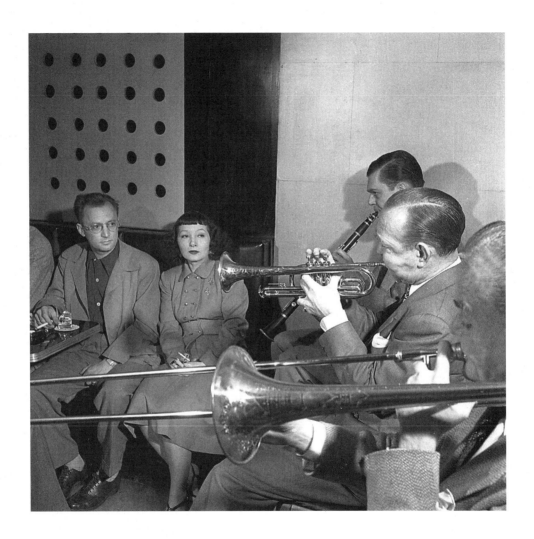

Nelson loved jazz and revered the night club called Jazz Limited. He also revered the foxy Asian lady, Ruth Reinhardt (next to him), who co-owned it with her famed musician husband Bill Reinhardt—shown playing the clarinet. Nelson also loved amateur musicians like this teen aged trumpeter practicing in his family shack along the Wabash tracks, blowing note for note with a Louis Armstrong record played by Studs Terkel on the radio.

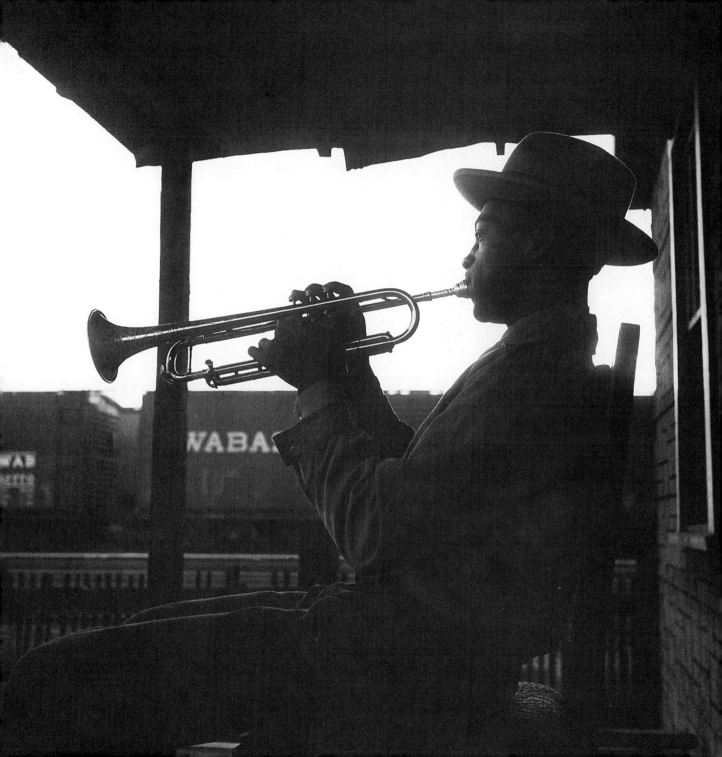

Big league pitcher-writer Jim Brosnan was a pal, a former Cub then playing for Cincinnati. In fielding practice he stumbled into the fabled Wrigley Field vines then clowned a few catches for my Nikon and for Nelson, who was along for the shoot.

In 1960 and 1961 I shot the baseball trading cards on back of Post cereal boxes. I was busy at this task the final week of the 1961 season when *Sports Illustrated* sent me to follow Maris as he attempted to break Babe Ruth's record of 60 home runs in one season—which put me a few feet away from Maris and his pal Mickey Mantle during batting practice. Alas, Maris didn't hit #61 until a few days later.

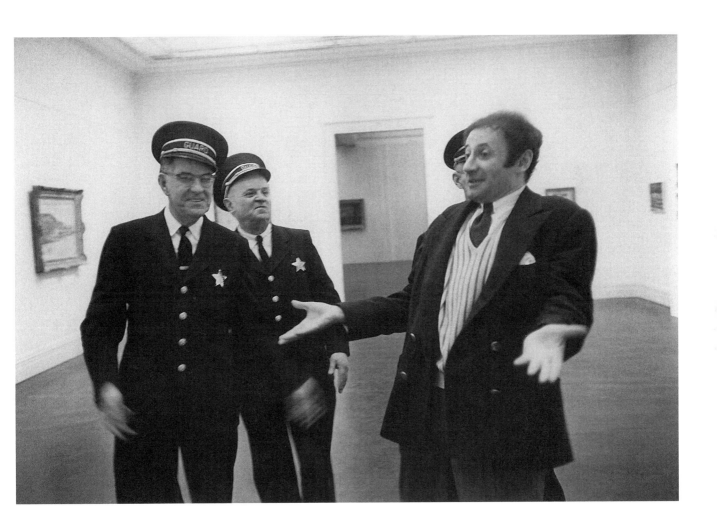

Marcel Marceau, Nelson, and I were escorted out of the Art Institute for shooting pictures with a hidden camera.

A matronly patron found our expulsion more interesting than Seurat's classic "Sunday in the Park" hanging on the wall.

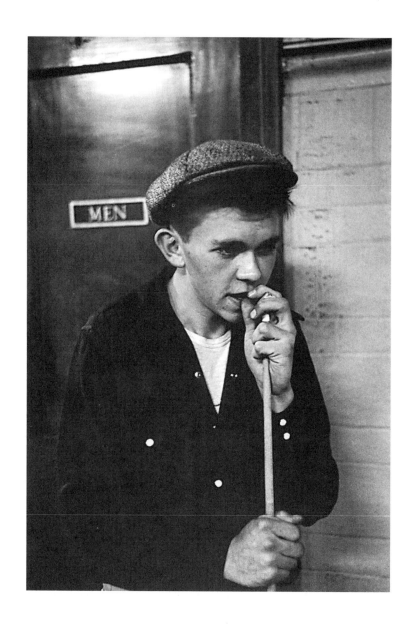

Marceau wanted to study neighborhood pool players, so we took him to a West Division Street pool hall, where I photographed the boy-man, and Marcel took the photo of Nelson and me that was eventually pirated by the great David Levine in *The New York Review of Books* (down to copying my conceit of placing Nelson behind the eight ball!)

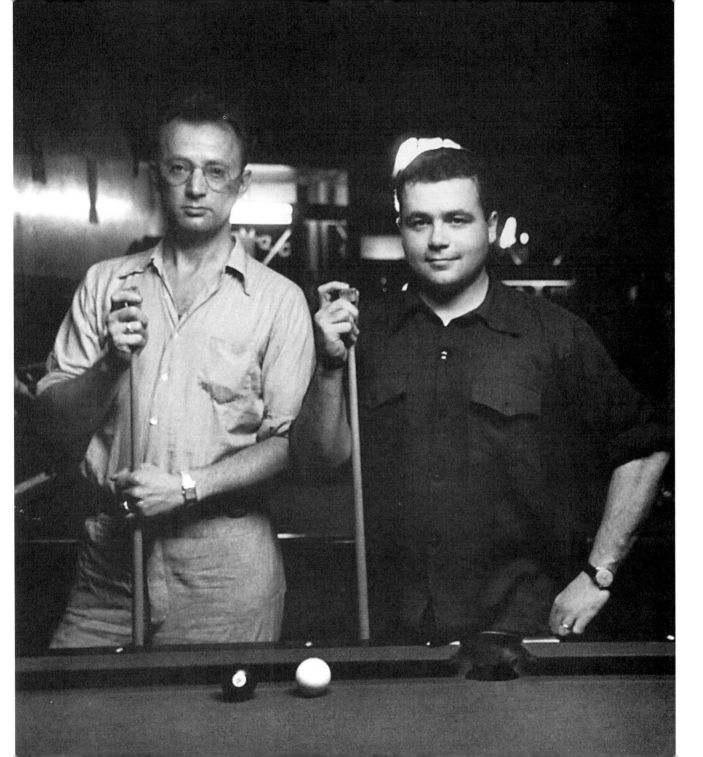

Nelson was a born family man who never had kids of his own. When he stayed over at our Chicago apartment he loved to make up stories for my kids and draw cats for them, as he did in some of the books he autographed. Here he shows Richard his technique as his godson Harmon tries his own at left. My older daughter Jane, now a famous attorney, but then the best artist in the group, watched the lesson. Years later, in 1976, at the house sale he held before moving to Long Island, he dragged Jane to his lap and elicited a promise from her to give him a discount if she ever represented him in court.

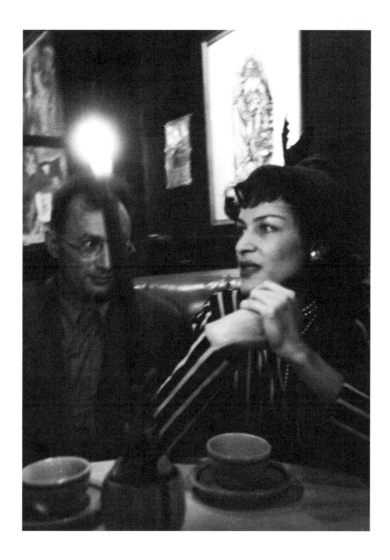

Marceau, who was always "on," does a fandango for Nelson and his date, poet Dorothy Ruddell Terry.

Nelson said, "I musta really loved Amanda—I married her twice."

Above, at the arts hangout on Rush Street called Riccardo's, Algren wooed "the best and sexiest woman I ever knew." She was actress Janice Kingslow, an African-American, who narrowly missed a part in the movie Otto Preminger and Frank Sinatra made of *The Man with the Golden Arm*.

Hugh Hefner loved Nelson's short stories and printed several of them. He was always welcome at parties in "the Mansion" on State Street. I made this portrait of Hef for a *Time* cover story in the late Fifties. This picture hangs in the National Portrait Gallery in Washington.

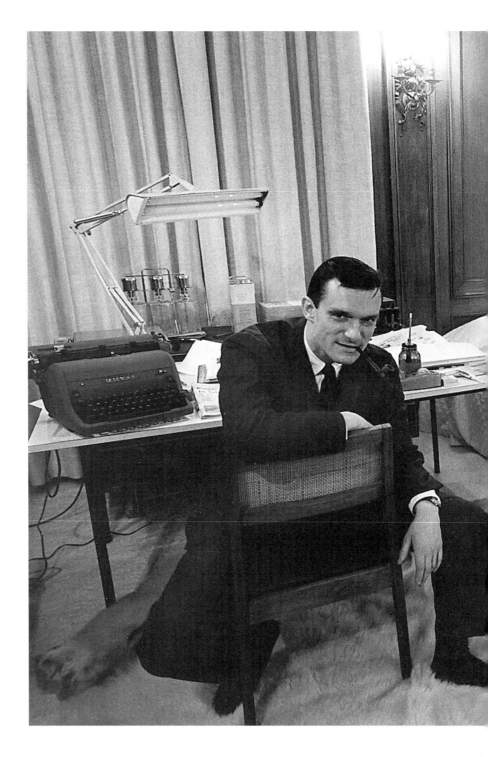

Brilliant as they both were, and as carefully as I briefed Nelson on his 127 Kodak, he and Simone, on a three week trip to Guatemala, managed to take 10 of the dullest rolls of snapshots I have ever seen. My heart sank as I examined the negatives in the darkroom. In only two frames are the great lovers identifiable. Said Nelson on viewing the disaster. "Mine came out better than her's. Look at this dog—unless it's a goat."

Before going to dinner at the Germania Club, I posed the lovers in front of his building. At the restaurant we sat next to the comic actress Joan Blondell. Nobody knew who the celebrities were except me. Joan made a slight effort—Had Simone ever heard of Dick Powell? "You know," said Nelson, "the waterfall man." "That is a fine title," said Frenchy.

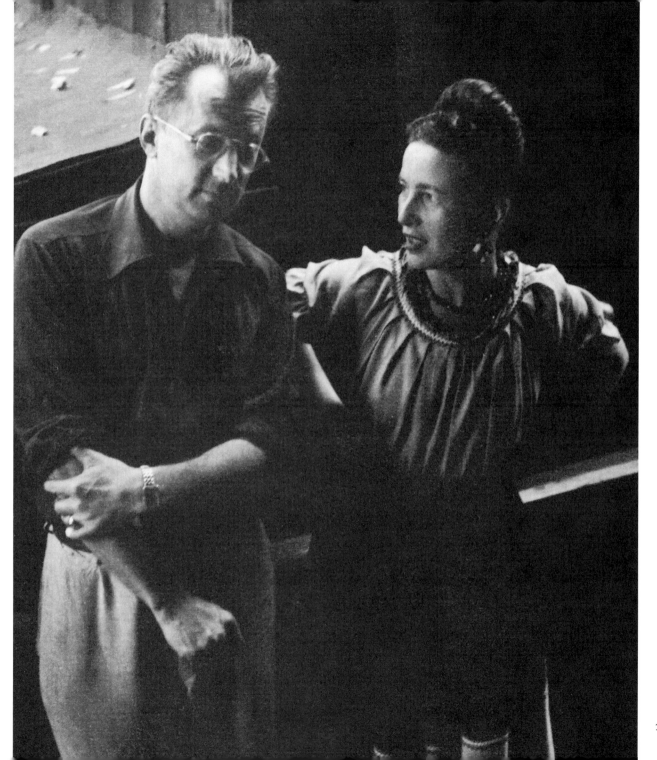

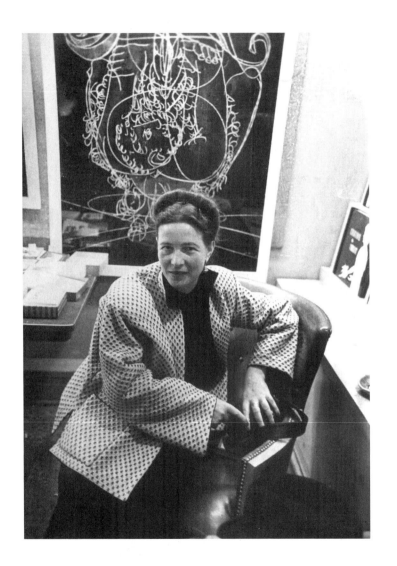

In Chicago, de Beauvoir accompanied Nelson on a few book signings, like this one at the Stuart Brent shop on Michigan Avenue. Later Brent would boast that Nelson and Simone screwed on a desk in Brent's back room. "Not true," Nelson said much later. "The only desks we ever did it on was my heavy writing desk on Wabansia and on Jean-Paul Sartre's desk in Paris when he was out with a high school girl. We ruined two or three hundred pages he had written that morning." One morning Nelson called me to find a bathtub for Frenchy. "She can't get into the Y." I borrowed a friend's apartment, and mindful of Nelson's remark that she rarely shut her bathroom door, I was ready with my Leica when she emerged. This picture has recently caused a stir in Europe when author Hazel Rowley used it in her best-seller, *Tete a Tete*, an account of the lifelong love affair between Sartre and de Beauvoir, with some sympathetic pages about Nelson.

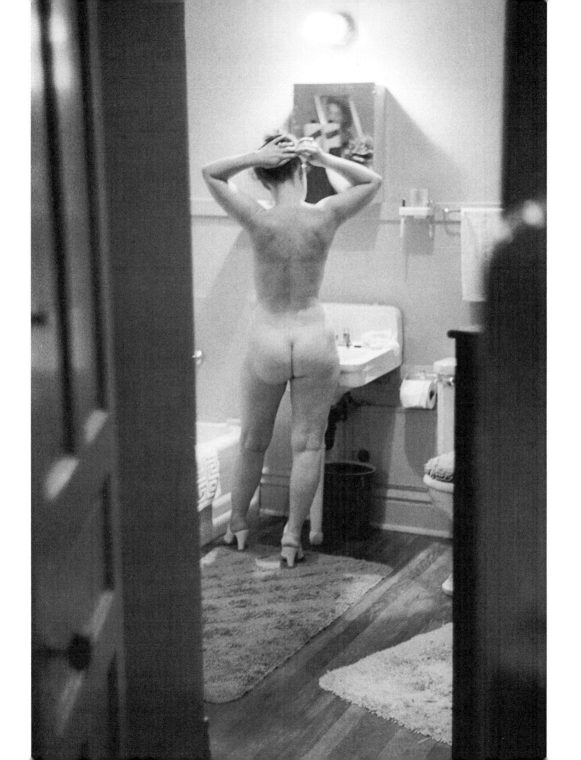

I could only imagine the emotions that welled up in Nelson as we visted his old apartment a few days before the wreckingball knocked it down. We ignored the "Keep Out" notice and climbed the stairs to his tiny flat for the last time. He had enjoyed countless meals and hot glasses of tea here, and in this space had enjoyed the sex and company of dozens of Chicago women, and had finally suffered the complicated love and confusion of his great affair with Simone de Beauvoir, his beloved "Frenchy." It was here that he set her on the track of the earliest of the American women's rights pioneers that culminated in her classic *The Second Sex*. It was here that "Frenchy," in the heat of sex, "swore she wanted to move to Chicago and live as my wife." He knew she was lying.

Jeanie,
MANY MOONS TOGETHER
AND MANY MORE to
COME! Richard
(Shay)

Chicago's Nelson Algren 11-13-
2007
Michael
Dey
ASAP
DAY

For Jeanie
with love
& memories via
Richard

RAShay

Seam

Many Meals together

Many Many Make to

And Make Richard

come Sickey

11-17-
2017
Michael
Rev
ASW
DAY

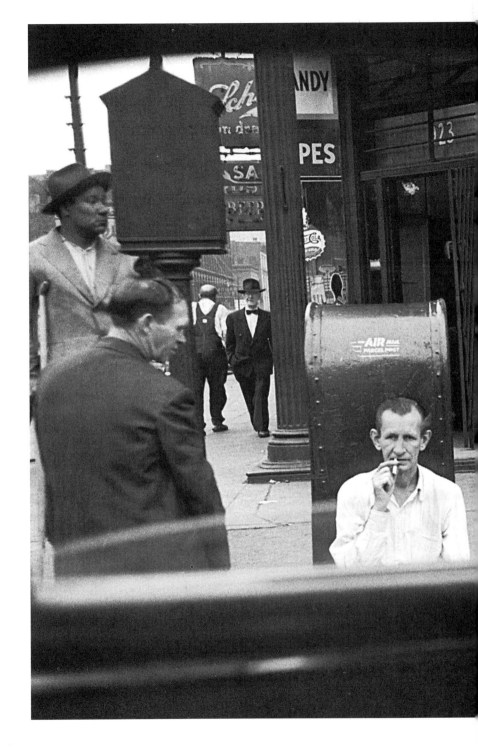

One Sunday, Nelson directed me to this Madison Street corner he loved, then scrunched way down so I could see the legless man (he had called "Schmidt" in a short story), and various other people starting their day. The *Chicago Tribune*'s vaunted art critic, Alan Artner called this picture "a masterpiece" of street photography.

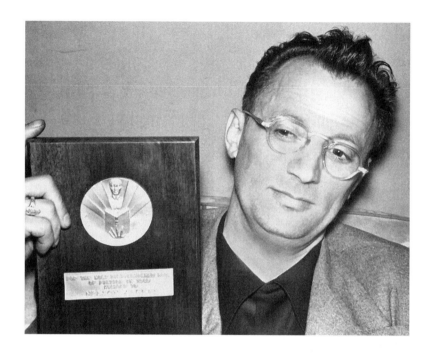

This winter night in 1950 at the Waldorf-Astoria in New York was the high point of Nelson's life. He received the first ever National Book Award for the best of more than 1,500 novels published in 1949. He received it, along with a check for $1,000, in front of the entire New York literary establishment from Eleanor Roosevelt (background), who quoted Ernest Hemingway's strong endorsement of Nelson's work. One sniveling follow-up article "quoted" Nelson as saying there was no money attached to the award(!). He wasn't impressed with the gold medal and seriously offered it to Florence and me. He later pawned it for $150, the same price (with a lunch tacked on) he took from a collector for the manuscript of *The Man with the Golden Arm*. He was pleased with himself over this "deal." "Hell," he said, "the thing's been printed already." A year ago Christie's reserve price for the manuscript was $150,000. The bidding got up to $130,000 but the current owner, the University of Illinois, turned it down, biding their time.

For their perspicacity in rounding up negatives, prints, slides, and disks, I'd like to thank my archivist, Erica DeGlopper, and the chief print maven at the Chicago Historical Museum, Leigh Moran, and her assistant Rachel Walther. The latter two have just devoted six months to mounting a six month exhibition called "The Essential Art Shay."

I am also grateful to Paul Berlanga, director of the Stephen Daiter Gallery in Chicago and his associate, Jess Mott, for their editorial assistance, and to Dan Simon and Jon Gilbert for patiently and expertly editing my words and layouts. I would be remiss not to thank my rare-book-dealer wife, Florence Gerson Shay, like me an old friend of Nelson Algren's, for helping me stick to my title and, alas, cut, cut, cut. (She cruelly ditched some of my favorite frames of Elizabeth Taylor, Frank Sinatra, Liberace, Jimmy Hoffa, Mafia chief Tony Accardo, and President John F. Kennedy—merely because their lives rarely touched that of Nelson.) I prevailed with the (page 154) snap of Hugh Hefner and Bunnies that hangs in the National Portrait Gallery. "Well," my wife relented, "Nelson used to go to the Mansion a lot between Simone's visits, for the food of course. And *Playboy* did print six of his short stories when he really needed the money."

—AS

PHOTO NOTE

Most of the pictures in this book were made with a usually-hidden black Model D Leica, guess-focussing my 35 mm Zeiss Biogon wide-angle lens (the rare, famous Marty Forscher conversion to Leica from Contax). My telephoto was a 135 mm Hektor. My film was generally Kodak Super XX rated at 100 ASA, very slow by modern

standards. This handicap made it necessary to shoot many of the indoor pictures at a quarter of a second without a tripod, and sometimes slower. The picture in the Washem Mortuary School, for example, was shot at one second, hand-held! My hand was steadier in those days! (Only one of my full-second hand-held time exposures, shot on a noir Mafia story, ever ran as a full page in *Life*.) My second camera was a 120 Rolleiflex, often aimed sideways, with me looking away from the subject. I had carried both cameras as a lead navigator in World War II. My first Leica, alas, was ruined in a fighter attack by Nazi FW 190s. (I have credit for a nose-turret kill of an FW 190 on this mission. The bent camera—it fell into the machine gun turret gears—now rests in the Leica Museum with the notation that it saved my life. A Jewish life saved by a German camera! It has come out recently that the then Leica president, at great personal risk, saved the lives of many of his skilled Jewish employees.)